ABANDONED
RESORTS OF THE
NORTHEAST

ABANDONED
RESORTS OF THE
NORTHEAST

RUSTY TAGLIARENI AND
CHRISTINA MATHEWS

AMERICA
THROUGH TIME®
ADDING COLOR TO AMERICAN HISTORY

America Through Time is an imprint of Fonthill Media LLC
www.through-time.com
office@through-time.com

Published by Arcadia Publishing by arrangement with Fonthill Media LLC
For all general information, please contact Arcadia Publishing:
Telephone: 843-853-2070
Fax: 843-853-0044
E-mail: sales@arcadiapublishing.com
For customer service and orders:
Toll-Free 1-888-313-2665

www.arcadiapublishing.com

First published 2020

Copyright © Rusty Tagliareni and Christina Mathews 2020

ISBN 978-1-63499-277-0

Typeset in Trade Gothic 10pt on 15pt
Printed and bound in England

CONTENTS

Introduction **6**

1 The Summit Honeymoon Resort **7**

2 Empire Hotel **19**

3 The Delmar and the Mountain Drive-In Theater **33**

4 Grossingers Resort **47**

5 Union Hotel **65**

6 Nevele Grande **77**

7 Pines Hotel **91**

8 Hotel Columbia **101**

9 Homowack Lodge **111**

10 The Divine Lorraine **119**

INTRODUCTION

For nearly two decades, we have traveled the United States, documenting overlooked relics of our collective past—abandoned properties, left to weather away, cast off by a society that no longer has use of them. They stand today as shadows, forms that resemble their former selves but only superficially. The lives that once congregated here have sunken into the umbra of our modern era, all but lost in obscurity. They linger still though, just faintly behind peeled paint and cracked plaster—an anemic beating of many hearts, of many lives, all slowly turning to dust.

Simply put, the subject of this book is abandoned resorts—massive establishments, some encompassing hundreds of acres, created with the simple purpose of entertaining people. A straightforward enough concept in theory, but in practice, these places often became far more than the sum of their parts. To many, these grounds were where their fondest childhood memories were created, where couples spent their first dates or even honeymooned. The properties of these resorts are littered with the consciousness of untold thousands of people, much of which is now concealed away by wild-growing briers and weeds. Walls where once families bonded, where lives were shaped and formed, now crumble and fall away.

When we leave a building behind, we too leave behind the stories and teachings which it holds. To forget a place is to forget all that transpired within it and resulted because of it. So let us now peer into the gloom and eulogize these grand establishments for all they once offered. Here they shine one final time.

Rusty Tagliareni and Christina Mathews
AntiquityEchoes.com

1

THE SUMMIT COUPLES RESORT

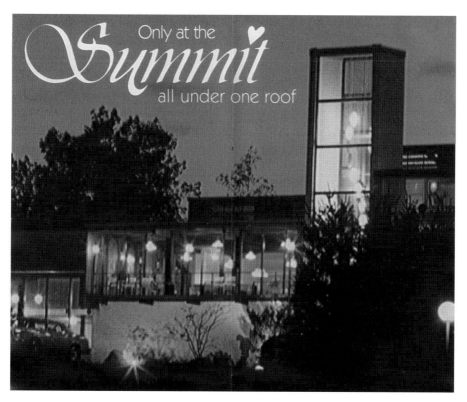

In the densely wooded Poconos region of Pennsylvania can be found the shell of what was once a premier honeymoon resort. Fallen from grace, it weathers away, unseen. Though battered and broken today, things were much brighter some decades ago. Upon our visit, tucked aside in a corner of what used to be the lobby, we chanced upon a box of vintage brochures—their pages as vibrant as they were outdated, advertising the amnesties that the Summit was at one time renowned for. Throughout this chapter, we will share scans from those pages with you, juxtaposed with our imagery from the present day.

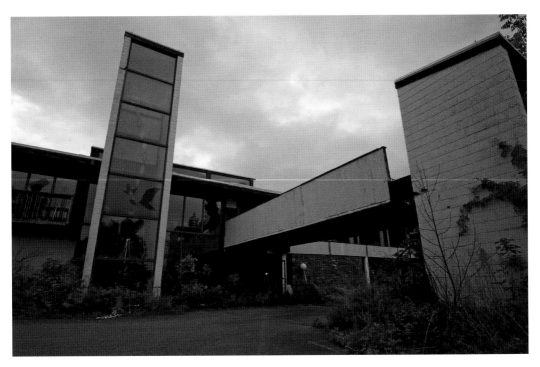

The Summit Resort opened in 1968, at the absolute zenith of the honeymoon resort era in the Poconos. Yet what is shiny and new one day is worn and outdated the next, and by the 1990s, the honeymoon bubble had burst. The resort hobbled on for years in a mostly vacant state before shuttering for good in 2002.

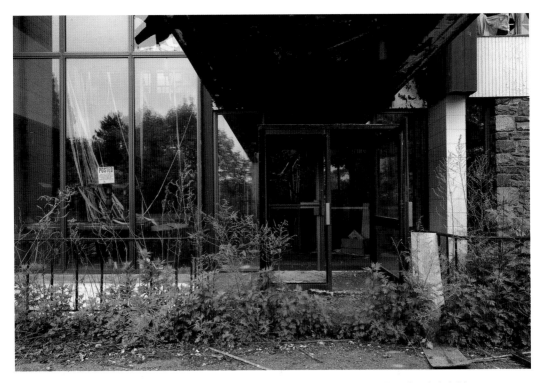

The main entrance is now shattered into thousands of pieces upon the cracked sidewalk and potholed driveway.

The lobby, once impressive with its walking paths over an indoor brook and planted forest, is now ransacked and covered in streamers of receipt paper from the booking office. All the plants and trees here have been dead over a decade, the last remaining hues of green belonging to the plastic ferns and 1960s "avocado green" paint job that adorns a two-story cinder-block wall.

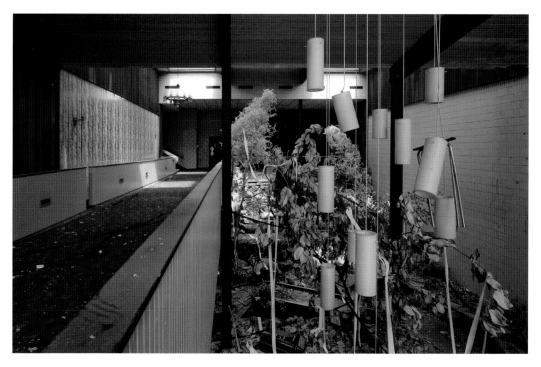

A partial-view of the ravaged lobby, as seen from the second floor. From this balcony, you can see just how tall some of the indoor trees grew before their untimely deaths.

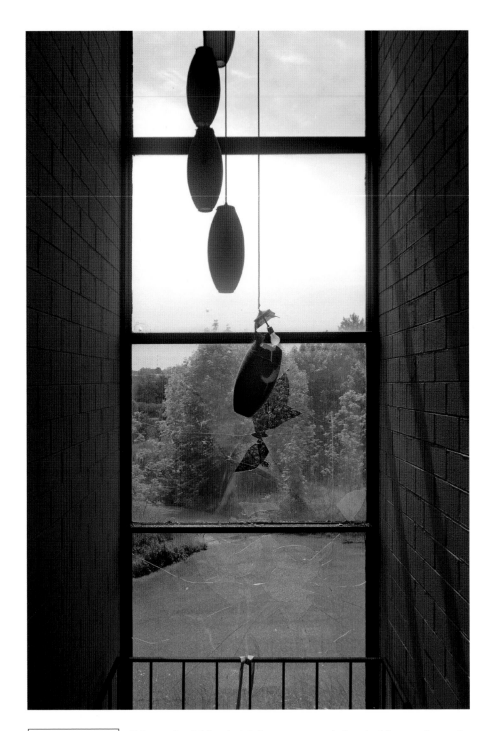

This massive lighting installation was once a hallmark of the resort, seen by everyone who visited the property. For over thirty years, it shined, displayed in the glass tower on the front of the resort.

Scan the QR code or visit bit.ly/SummitResortVideo for an exclusive video.

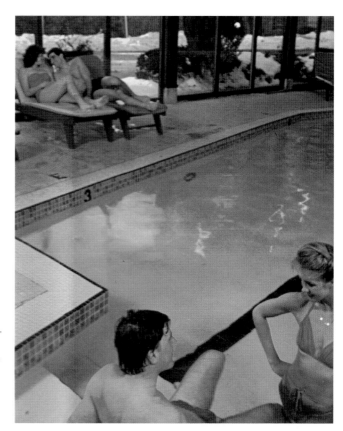

Right: An old photo from the advertisement brochure depicts happy couples gathering around the clear waters of the indoor pool.

Below: Lounge chairs still line the deck of the pool, though today it sits mostly empty; what little water remains is stagnant and murky green.

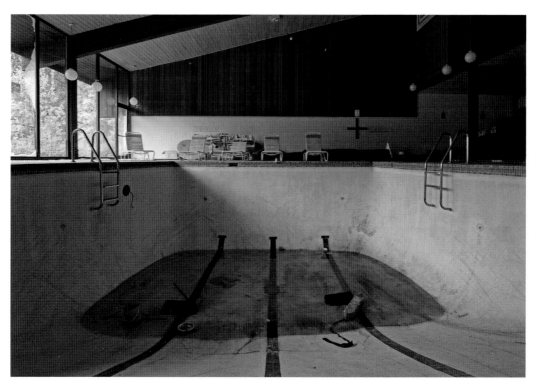

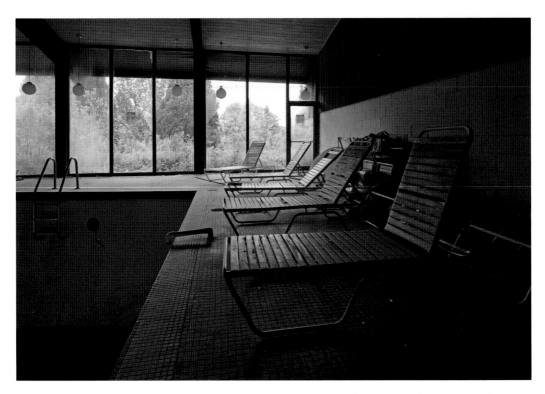

The room containing the indoor pool was surprisingly dark, even with a row of large bay windows lining a wall. It was also one of the more unnerving areas at the old resort. Gone were the muffled conversations of guests, the cheesy canned music that once played on the resort speakers, or constant splashing of water in the pool. Everything was overwhelmingly still and intensely silent. That silence, coupled with the open space and cement floors, created an echo chamber that repeated back even the most subtle of sounds over and over again.

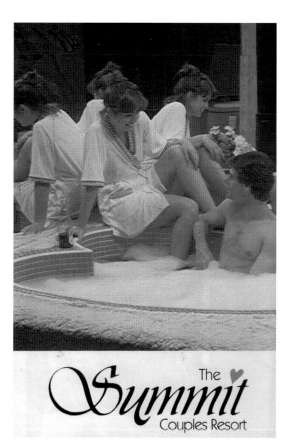

Right: Another page from the old resort flier, this one showcasing the more romantic fixtures of the cottages and suits. In this case, we see a couple from ages passed enjoying their evening in one of the Summit's iconic heart-shaped hot tubs.

Below: The same tub today. Romance has been replaced by mildew, and glitz with broken glass.

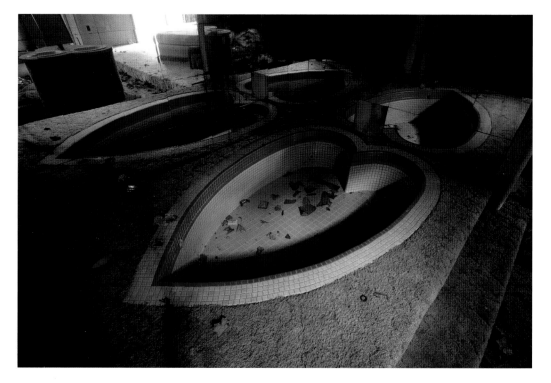

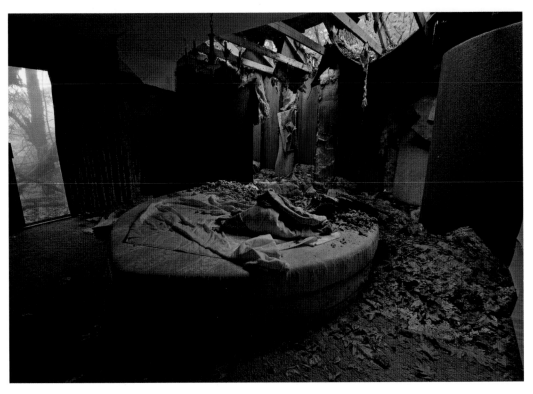

What better to accompany a heart-shaped tub than a heart-shaped bed and vanity?

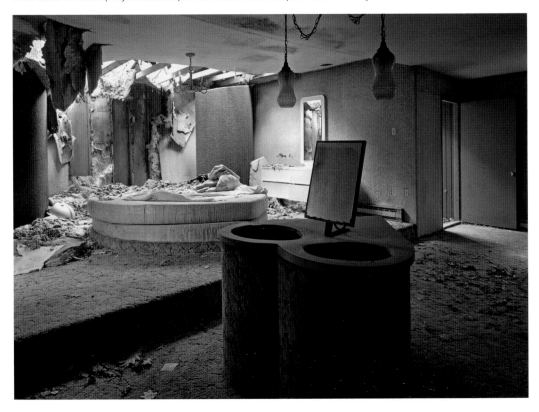

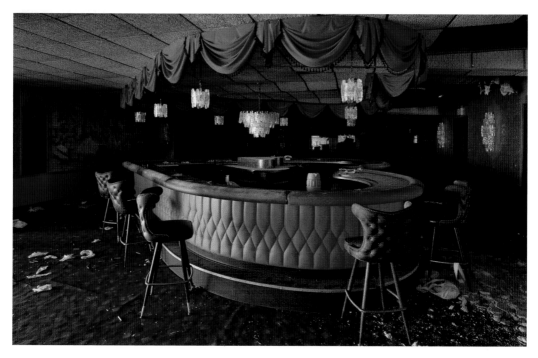

Even though much of the Summit's fanfare was directed at the couple's suits and their heart-shaped tubs, the most popular spot in the resort was the lavish, Arabian-themed lounge: the "Club Scheherazade." Walls were covered in hues of red, gilded in gold, culminating at the center with an immense circular bar—heart-shaped, of course.

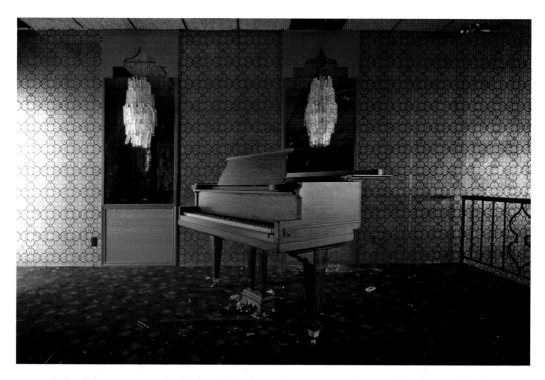

In the dining area across from the bar still stands a baby-grand piano. Once providing visitors with backing tracks to their evenings, it is now disused and out-of-tune.

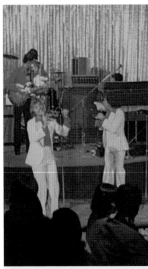

Beyond the bar, concealed in utter darkness, we discovered the former performance stage. Upon it, golden curtains still hang, soiled and faded. Rows and rows of seats outlined the dancefloor; this was a space clearly built to entertain hundreds at a time. Now though, it was just the two of us, alone with our flashlights.

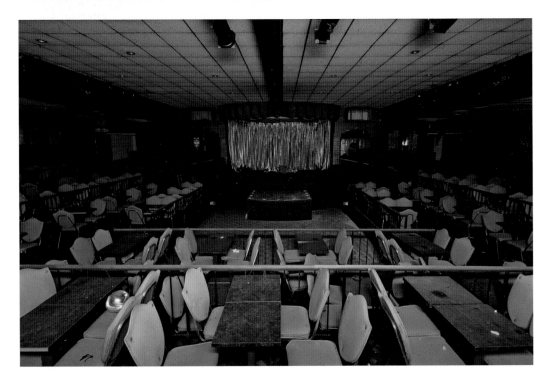

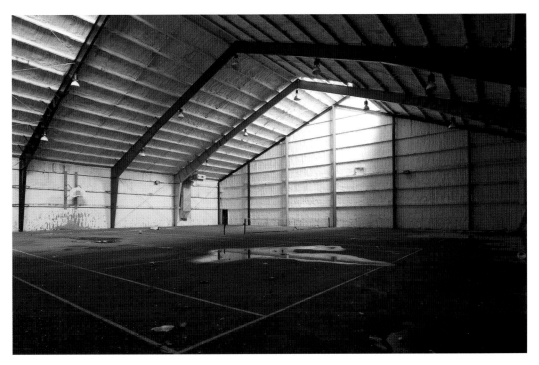

Any resort worthy of the name was expected to include some form of recreational pursuits, and the Summit was no different. A short walk from the central hall would find you at the activities building; within were spaces for mini-golf, tennis, racquetball, and basketball to name just a few.

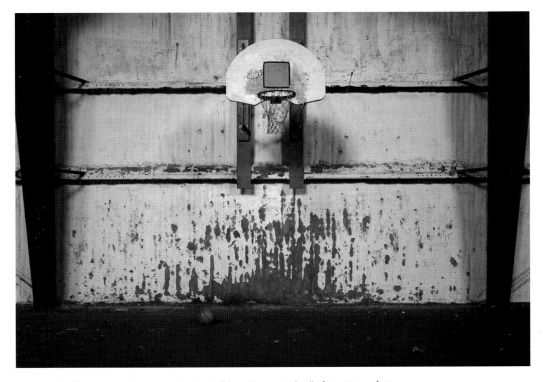

The fiberglass wall below the basketball hoop has worn badly from years of use.

One of the dozens of rental cabins that dotted the forest around the resort. Though many appeared to be in sound shape from the outside, the condition of their exteriors belied the rot within.

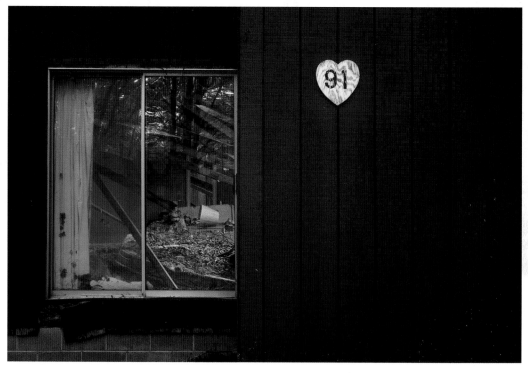

Looking through the window of a cottage to see the utter collapse of the roof that had come to rest upon a heart-shaped mattress.

2

EMPIRE HOTEL

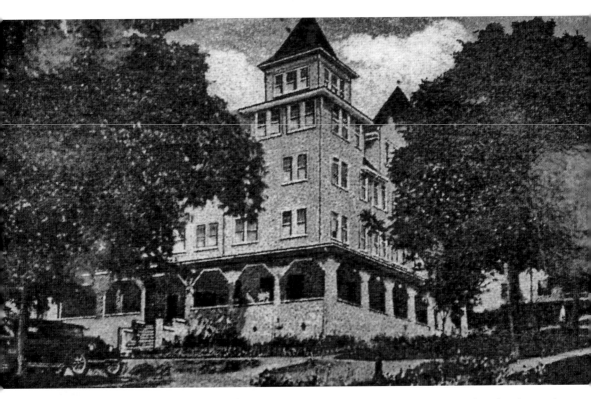

Peering out from a thin wood line above the small town of Sharon Springs, NY, is the weathered and warped remains of the Empire Hotel. Inaugurated in 1927, none likely could have imagined the state that the well-appointed resort would eventually decay to.

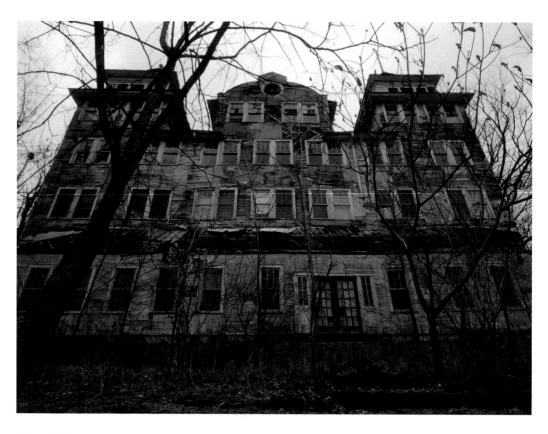

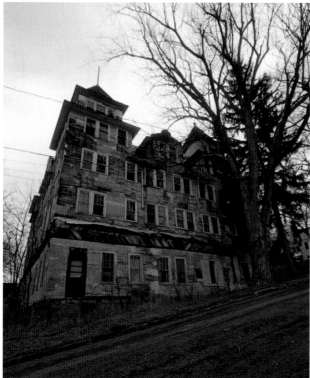

Over time, as the façade deteriorated and fell away, much of the structural lumber of the building had come to be exposed. This wood, which supported the five stories of rooms and halls that formed the hotel, came to be water-stained a dark brown. It all gave the Empire the impression of being perpetually waterlogged, which it very well might have been.

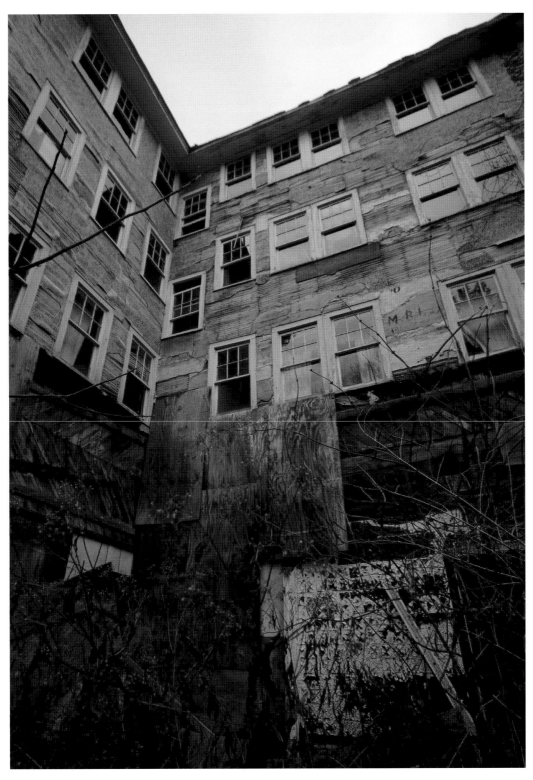

The excessive moisture had buckled and bowed the venerable building from top to bottom. Inside its walls, one was hard-pressed to find a single level surface.

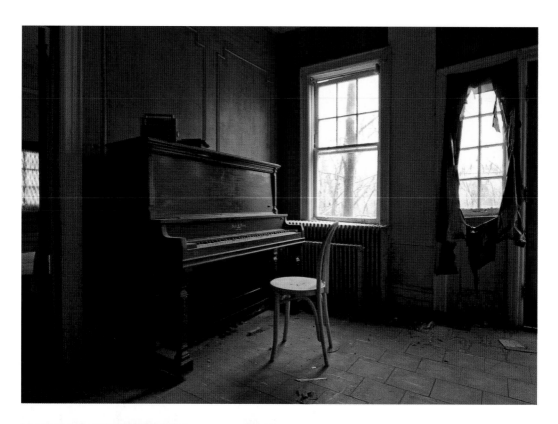

Above: Though we had paid a visit in the early spring, the embrace of winter had yet to surrender the depths of the former resort. As we passed from daylight into the darkness that clung within, we were hit by a wall of icy air far more suited to the recesses of some subterraneous cavern than a hotel lobby.

Left: The Empire operated successfully for some decades, principally servicing patrons of the town's then-famous sulfur bathhouses. Though once tremendously popular, these baths eventually fell to the wayside, and the hotel followed suit.

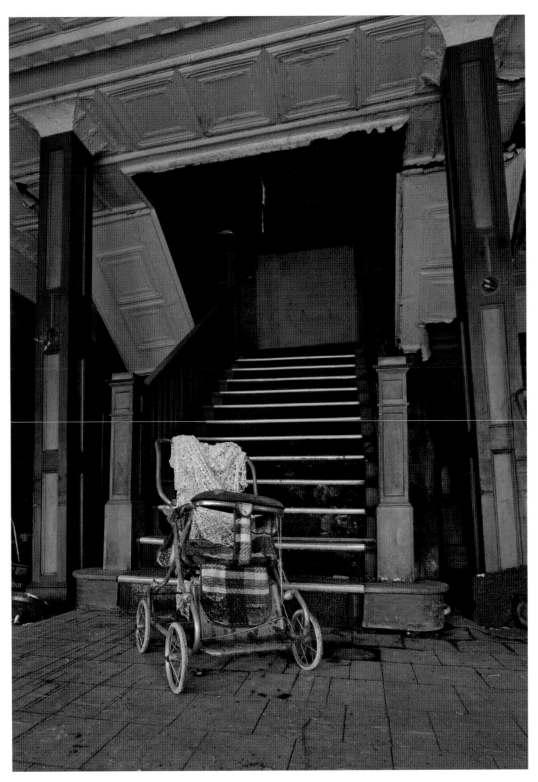

The main staircase—a crooked path that stretched upward to four levels of empty, distorted bedrooms and the thick shadows that covered them.

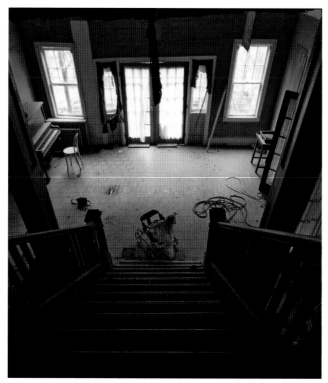

So greatly had the cycle of seasons curved and bent the old resort that one struggled to find a horizon line when walking about, and the effect proved vertigo-inducing at times. For the remainder of this chapter, please bear in mind that no matter how crooked things may appear on these pages, every photograph was captured with the camera completely leveled on a tripod.

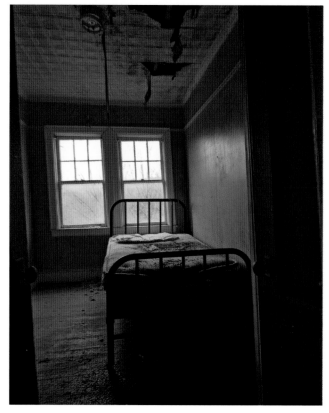

One of dozens of bedroom chambers, the floors and walls of which listed in unnerving ways.

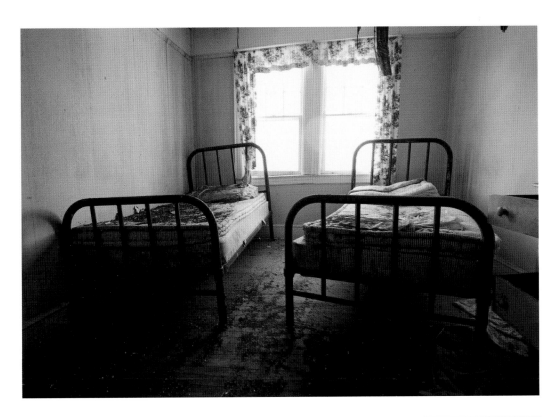

Above: The wings of the hotel were slowly sinking, each in a different direction.

Right: The roofing was taunt from the strain of holding all these decaying parts together and had begun to tear in sections, allowing yet more water easy access to the already saturated framework.

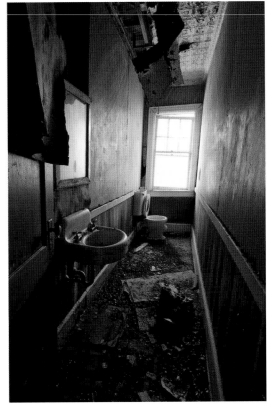

At one point while filming, we were interrupted by a deep and pronounced gurgling sound emanating from directly overhead. Somewhere above us, past the blackened ceiling, the hotel was literally coming apart at the seams.

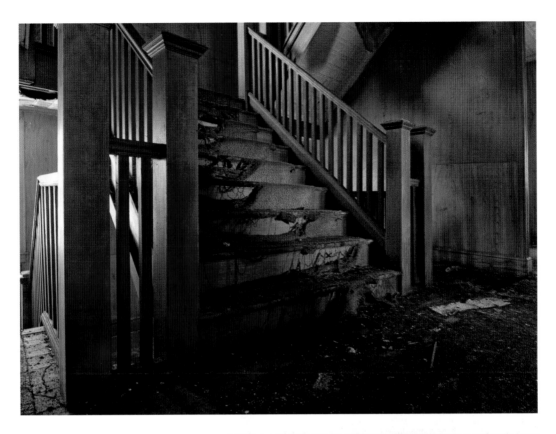

Above: The central staircase—one sole respite from the dizzying effect of the disjointed, sagging rooms and halls. Not only was this staircase the most level piece of the entire resort, it was also by-and-large the foremost support holding the building from utter collapse.

Right: A claw-foot tub gazes out from a third-floor window, patiently awaiting the end.

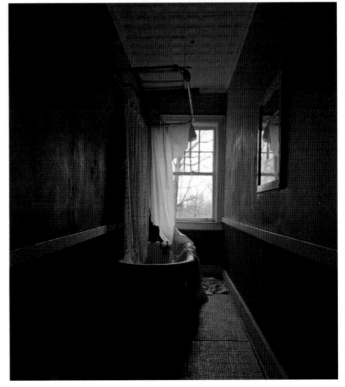

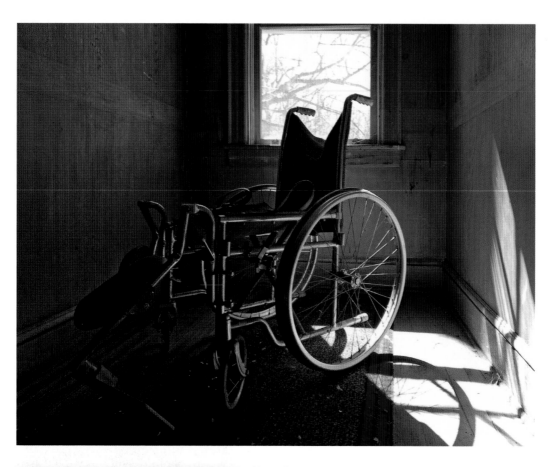

Above: A lone wheelchair wanders the uppermost floor of the Empire, likely the last remaining of a small fleet once used to aid elderly or disabled guests.

Left: This upper corridor may appear level, but every room off of it dangled at different, precarious angles.

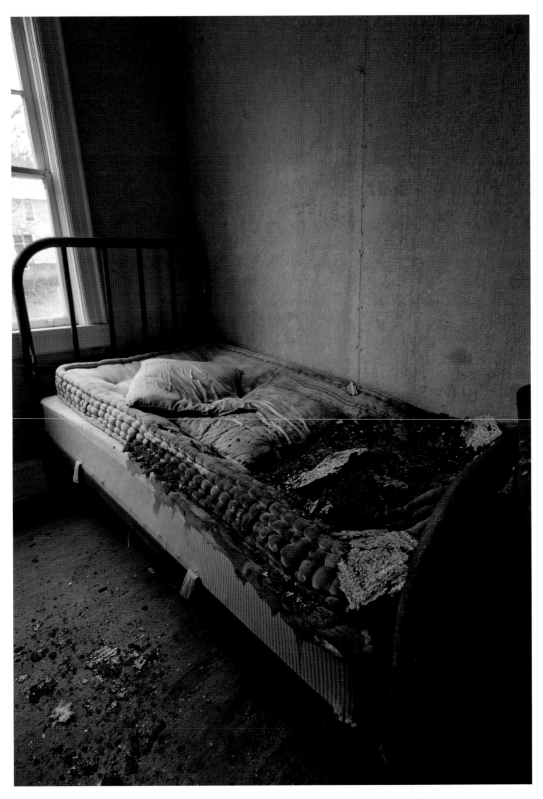

A bed that had spent years situated directly underneath a small patch of leaking roof.

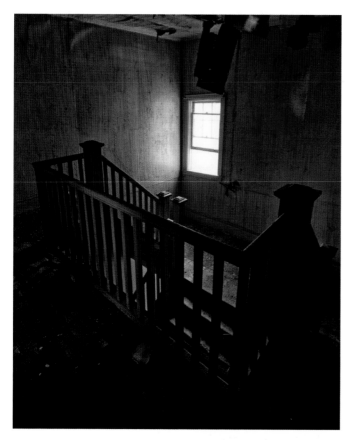

The top floor of the stairwell that ran the center of the resort—the spine of the building, bent but not yet broken.

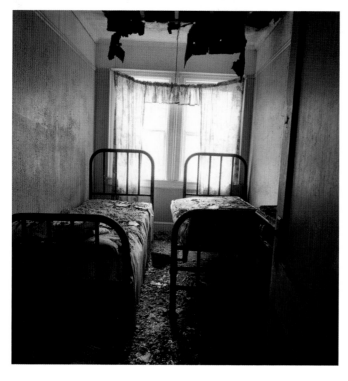

Skeletons of beds.

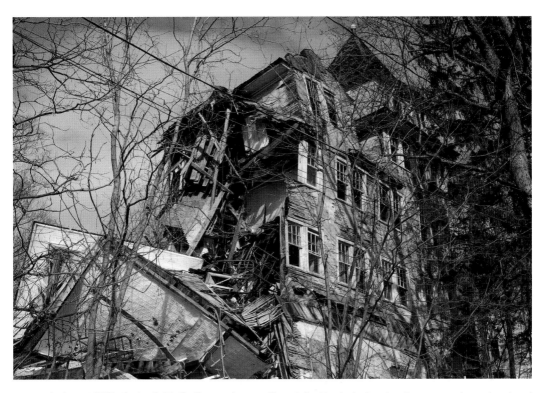

In August 2019, the inevitable finally came to pass. Though the Empire had endured many years in an abandoned state, a strong summer storm finally proved too much for its tired walls to bear. At the time of writing, the once-popular hotel has been reduced to little more than a heap of debris on the side of the road. A single tower remains, though it leans farther with each passing season.

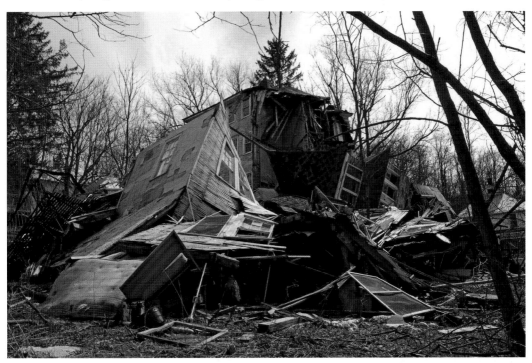

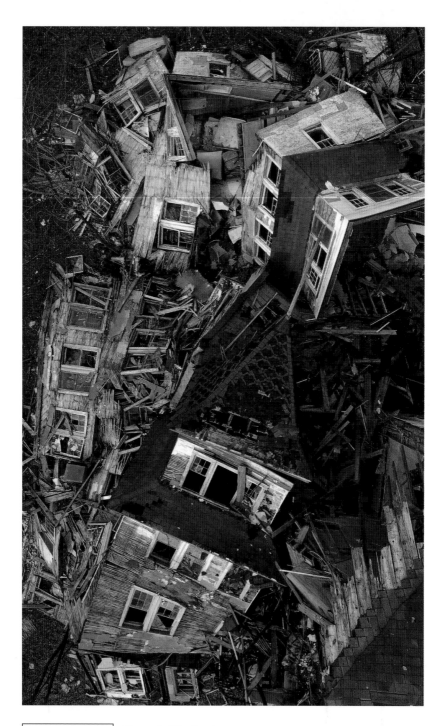

The end of the Empire.

Scan the QR code or visit bit.ly/EmpireHotelVideo for an exclusive video.

3

THE DELMAR AND THE MOUNTAIN DRIVE-IN THEATER

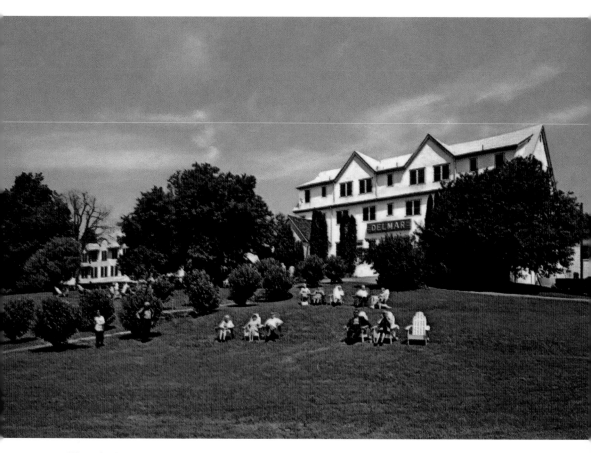

When the Delmar opened in the late 1920s, it was just one of the nearly countless resorts that came to nestle in the Catskill Mountains of New York. Though smaller in stature than some of the better-known establishments that neighbored it, the Delmar earned a modest success through its unique range of accommodations, including the option for bungalow-style lodging as well as easy access to a drive-in theater that sat adjacent to the resort.

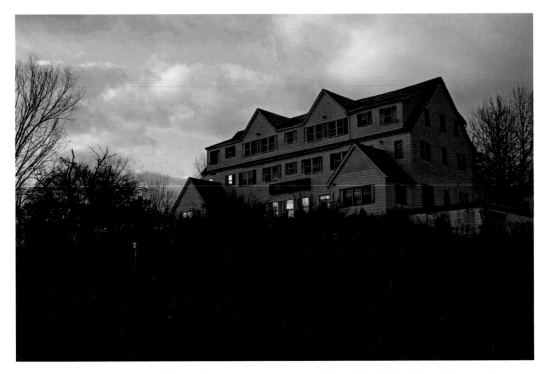

As popularity faded through the 1980s, the Delmar resort was eventually forced to shutter. In time, the property traded hands to become "Redirections," a drug rehabilitation clinic, before shifting once again to become the "Le Minette," a restaurant venture that proved short-lived.

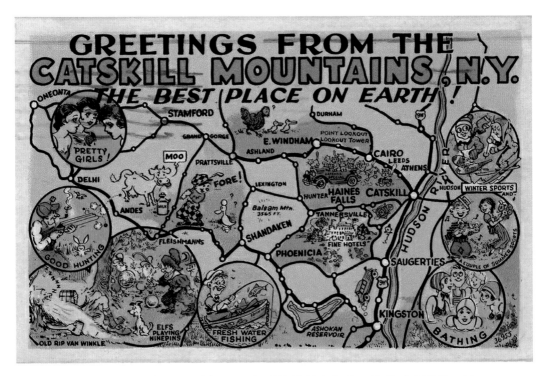

An old postcard image showcasing some of the recreational highlights to be found in the Catskill Mountains.

The hotel entryway was barren but full of debris. The building obviously has structural issues as well, and at some point in recent history, a large 4 × 4 piece of timber was installed in the center of the room to help support the weight of the floors above.

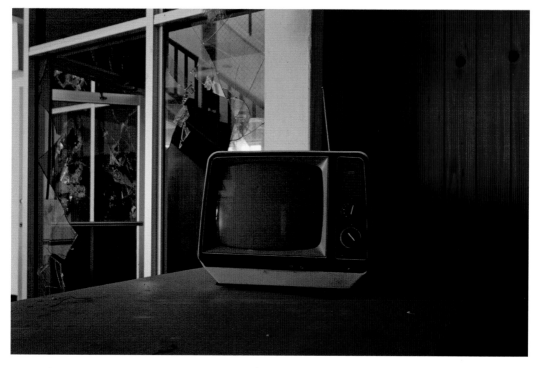

An old television sits at the front desk, likely used by the clerk to pass time between guest check-ins.

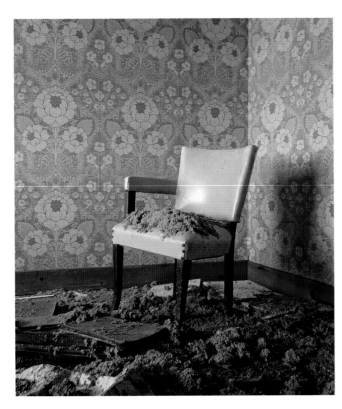

Left: A vinyl chair and amber damask. Crumpling ceilings on the higher floors have covered most surfaces in a thick layer of wet insulation.

Below: Most of the bedrooms had been cleared out prior to the resort being permanently shuttered, but some survived intact—mildewed, rotten, and curiously floral.

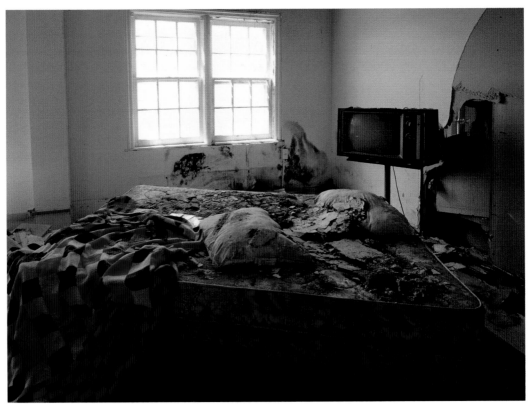

Above: Over a small street that crosses through the property can be found the old bungalows. As decayed as the resort proper had come to be over the years, these much simpler structures fared much worse.

Right: The old bungalow had weathered poorly, yet many relics from their days as a resort remained. Here, an entire kitchen nook still survives, though considerably more lopsided than some decades ago.

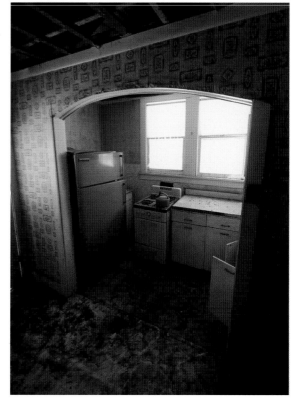

Vintage wallpaper kindles the imagination in and of itself. We personally have an affinity toward it, as one cannot help but wonder what these walls and their patterns have observed through the years.

Gazing toward the front entrance from within a collapsing cottage.

The passing years exert their toll, altering the landscape in dramatic ways.

However, inside, time seems to pass more slowly.

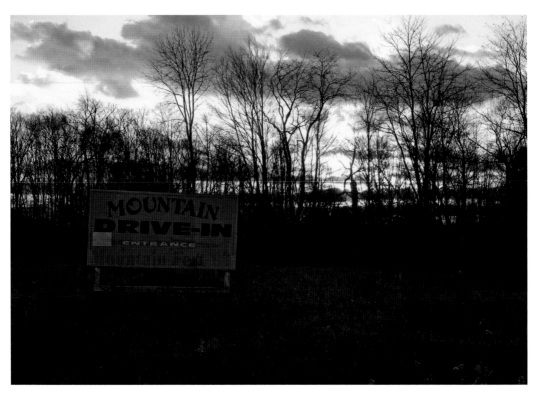

On a parcel of land situated behind the old resort can be found an overgrown field that was once the Mountain Drive-In theater.

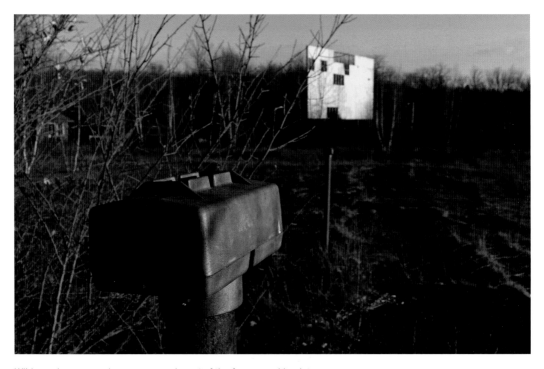

Wild-growing grasses have consumed most of the former parking lot.

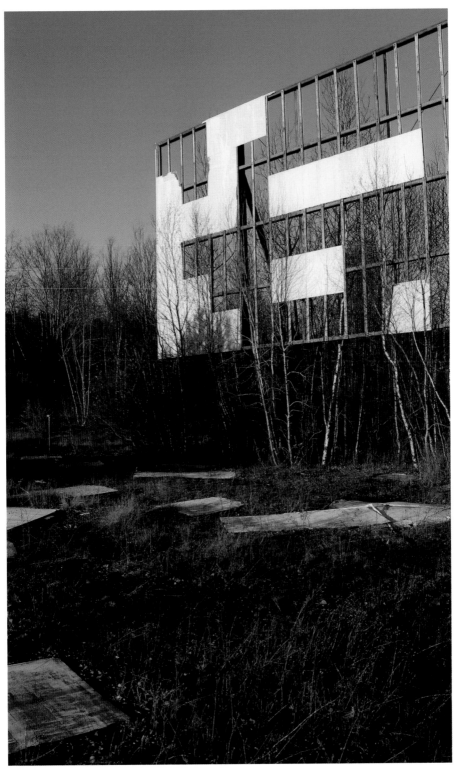

Years of storms and wind have torn the old theater screens apart, scattering their pieces throughout the grass and thorns that have grown up around them.

The overgrown drive-in at sunset; ranks of poles still line the fields. These posts once held the speaker boxes and indicate where movie-goers would have parked years ago.

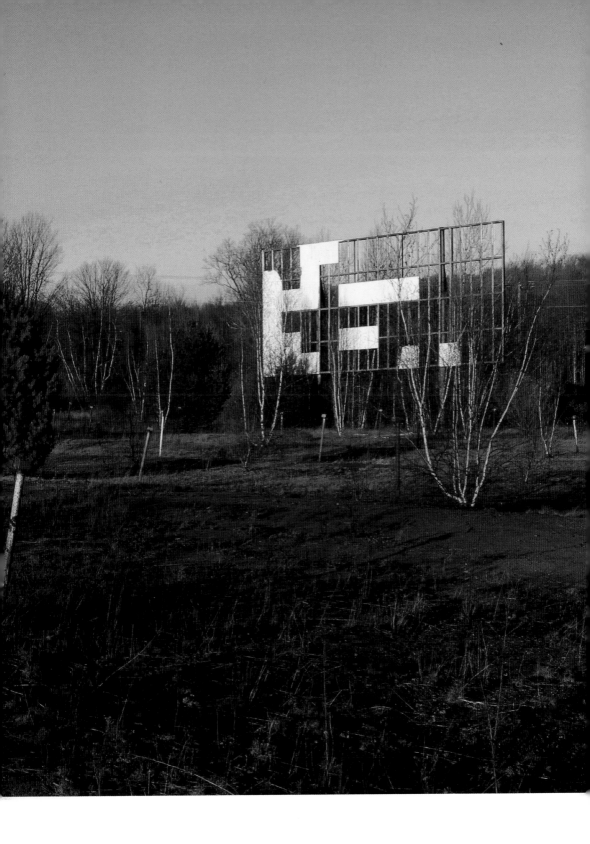

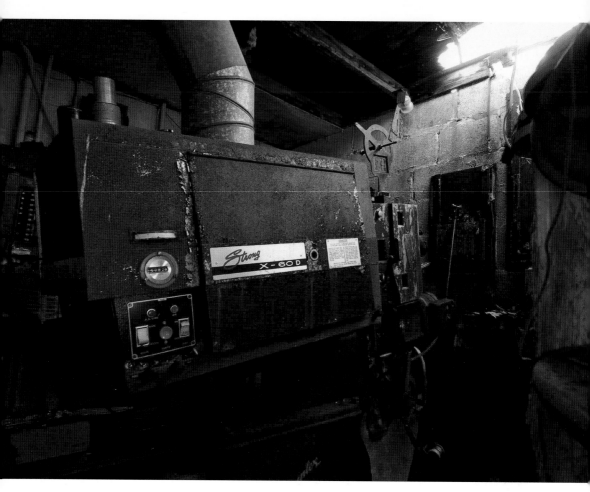

A rusting film projector in the back room of the projector house; the roof above it has begun to cave in.

Scan the QR code or visit bit.ly/DelmarResortVideo for an exclusive video.

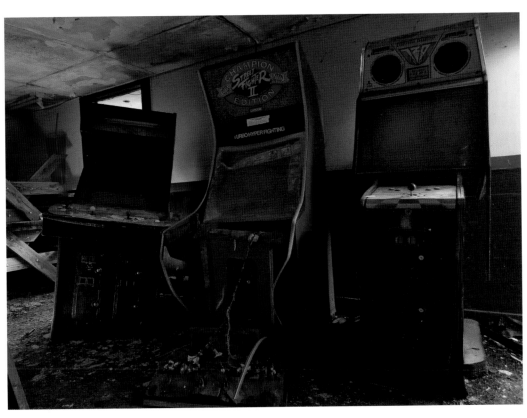

Three arcade machines still stand in the concessions area, though for how long remains to be seen.

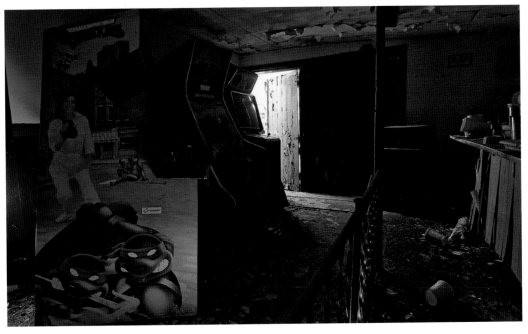

Across from the arcade machines, the concession counter peels apart, spilling popcorn buckets and pieces of itself upon the floor.

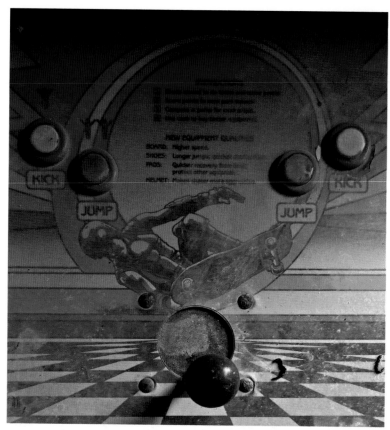

Left: Dust-covered arcade controls.

Below: The once-illuminated sign for the Mountain Drive-In theater, broken and fallen. It now lays overgrown on a patch of dirt next to what was the entrance driveway.

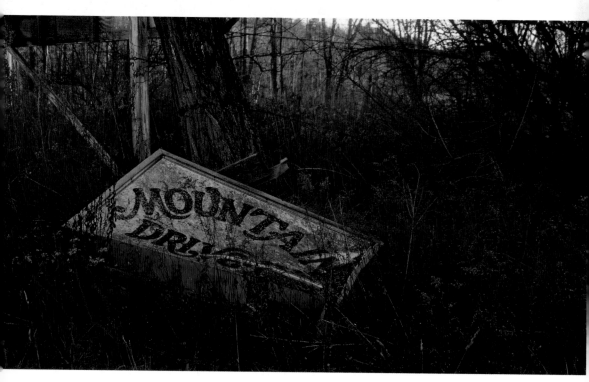

4

GROSSINGER'S RESORT

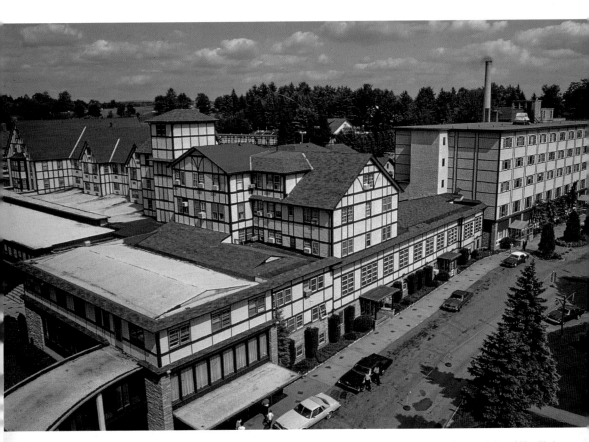

Born of humble beginnings, Grossinger's Resort started its life as a single house in the rustic mountains of New York State that let out a single room to travelers. It was family run—the husband managing operations and maintenance, his wife the cooking and cleaning, and their daughter acting as a hostess. In 1919, the original house was sold in favor of a larger building on 100 acres. By 1972, the resort boasted thirty-five buildings on over 1,000 acres of land and entertained 150,000 guests annually. (*Photo by John Margolies, Courtesy of the Library of Congress*)

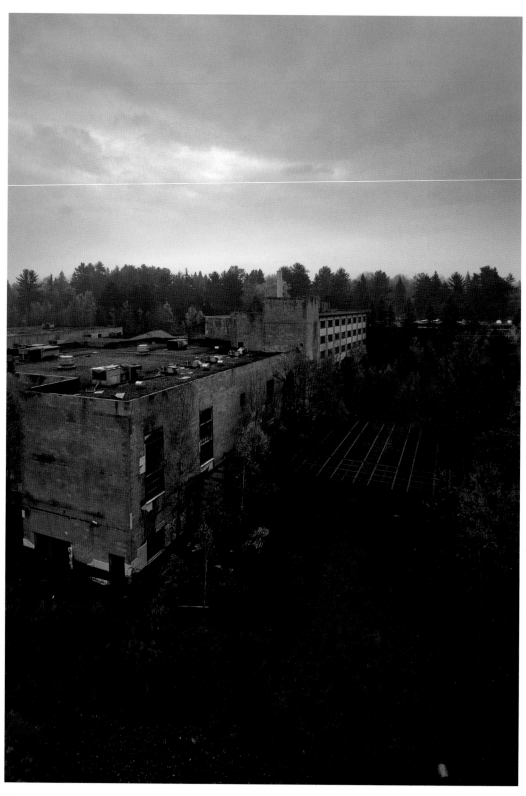

Upon our visit to the once-famous resort, the grounds stood in stark contrast to the vibrancy of its youth.

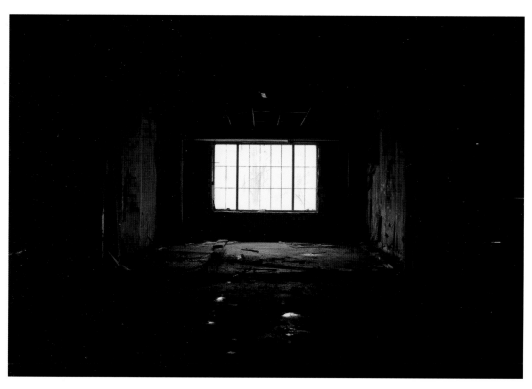

How dark it had become, how lonely.

Some elegance remained in the murk though, if you looked for it—whispers of a grandeur that had long faded.

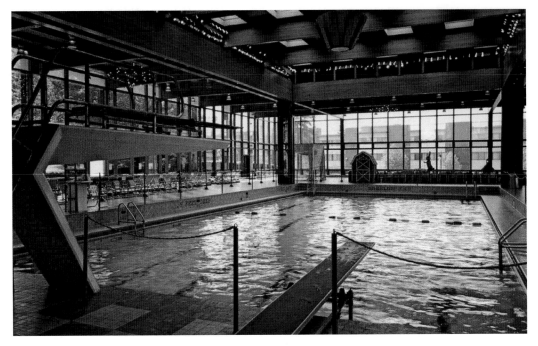

The indoor pool was one of the many remarkable features of Grossinger's Resort.

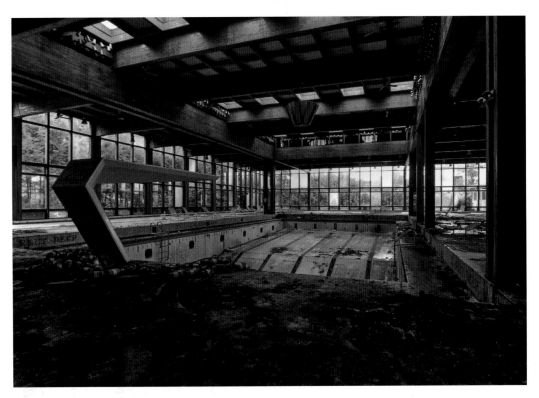

Even after the abandonment of the property, the pool remained a popular destination, this time for curiosity seekers wishing to capture a glimpse of the Catskill's golden era—to stand in the space, try to feel its history, and to envision a time so different and far-removed from today that it nearly seems a work of fiction.

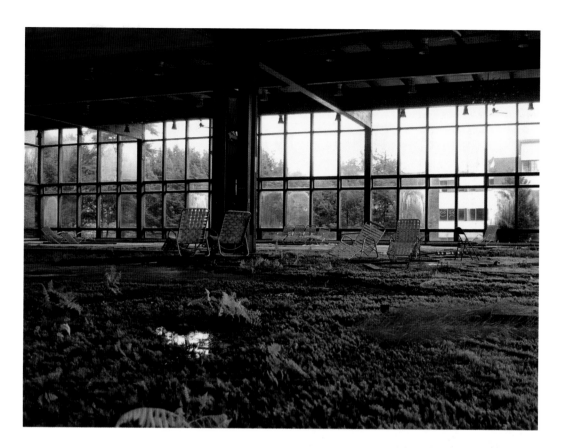

The glass walls of the indoor swimming hall, coupled with a rotten and dripping ceiling, combined to make a vast terrarium full of moss and ferns, dotted with plastic lounge chairs.

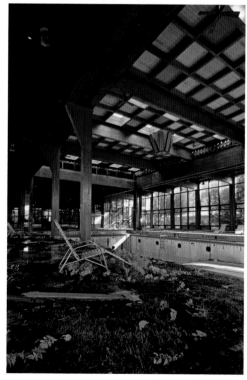

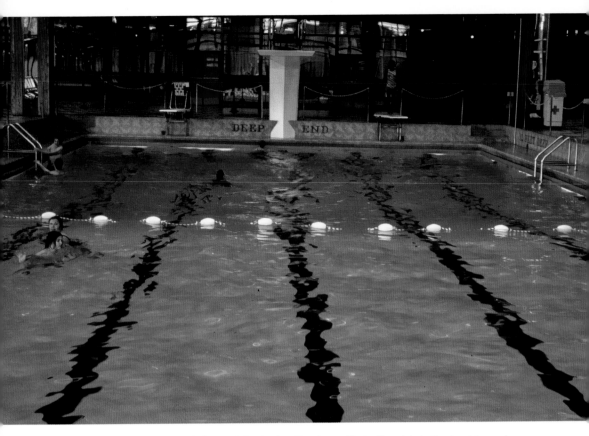

The indoor pool as seen from the shallow end, back when the air was filled with quiet chatter, laughter, and the aroma of chlorine. (*Photo by John Margolies, Courtesy of the Library of Congress*)

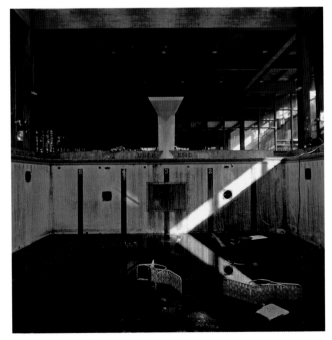

The air this day was humid with the perfume of the decaying beams that resided overhead. Suspended from the core of that rot hung a large geometric light fixture; though long dark, it must have been an extraordinary display when power still flowed here.

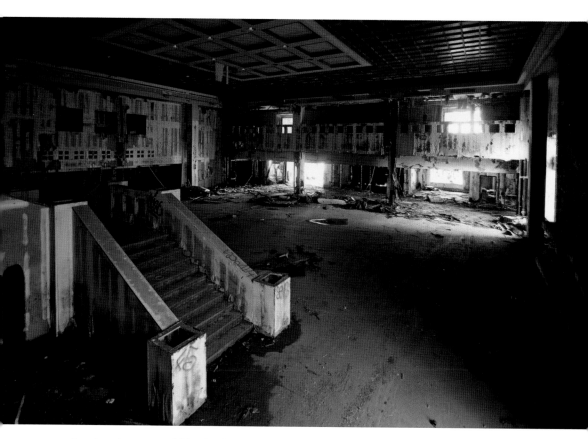

Grossinger's enormous lobby, dead before it was ever born. In 1986, the resort closed for what was thought to be a short hiatus, to refresh and modernize. This lobby was to serve as the grand entrance to a renewed resort, a striking first impression meant to leave guests in awe. Unfortunately, bankruptcy hit before it was ever finished.

In a closet at the end of a long dark hall, we came upon cases of blueprints and plans for the future resort that would never be. This particular page shows the main lobby.

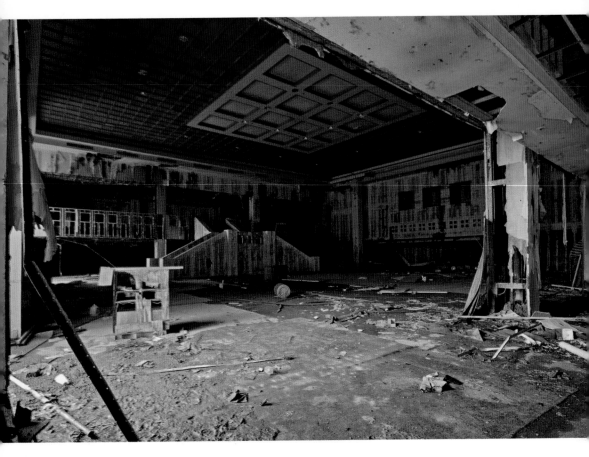

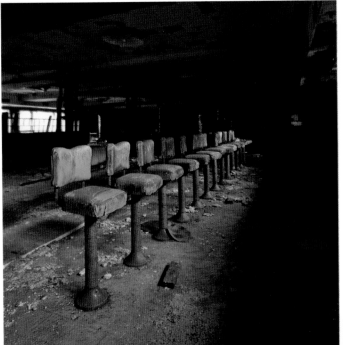

Above: The cavernous lobby from the perspective of a guest who was entering for the first time—one has to imagine it would have made for a remarkable display if it had ever been completed.

Left: A row of green stools line where a counter formerly stood in a dim and empty cave that was formerly the amusements and refreshments hall.

Above: An amber tower of suites, nicknamed the "Jennie G building," was the first impression for many visitors to the resort. Beyond being prominently located at the gateway to the grounds, the tower's nine floors were visible for miles.

Right: A storm rolls in over the abandoned "Jennie G."

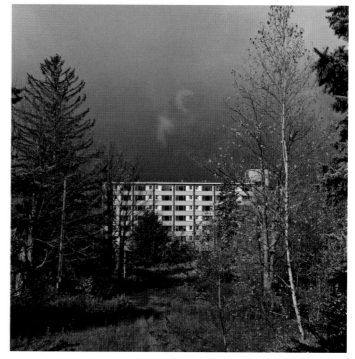

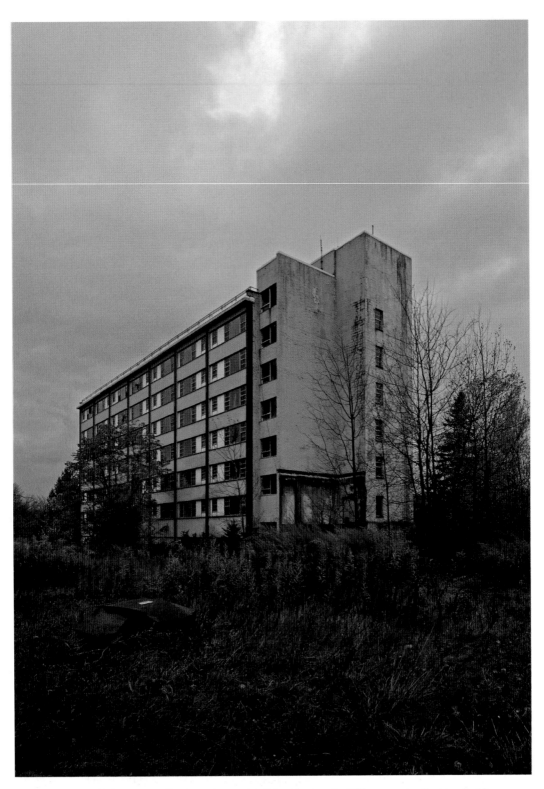

As the years passed, the tower grew more and more derelict, a ghost on the hilltop surveying the town that lay beneath it, forever reminding those below of an era long past.

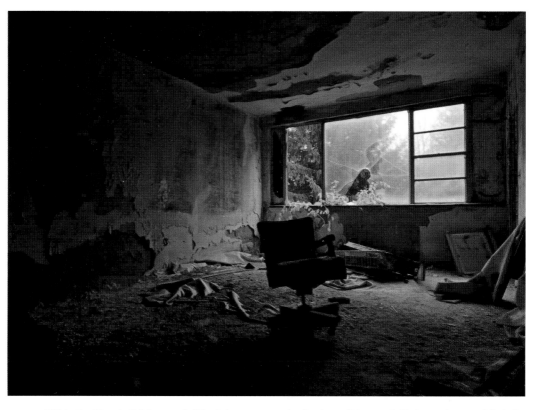

Within the "Jennie G," it proved difficult to even conceive the incredible crowds that once traversed its halls. Families, children, old and young—memories of generations all evaporated into the ether of those walls.

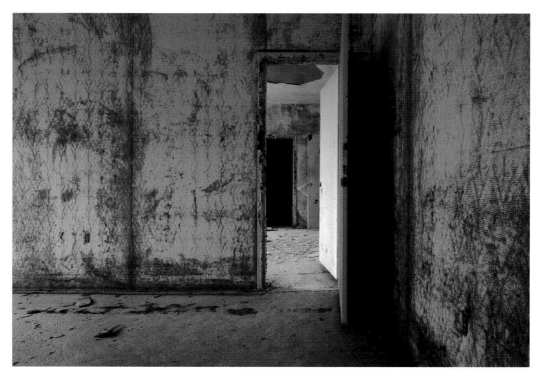

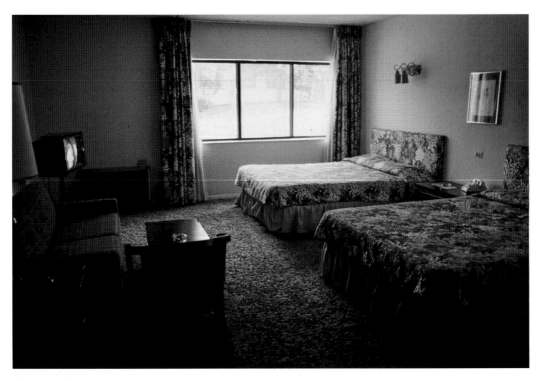

A guestroom as it appeared in 1977. (*Photo by John Margolies, Courtesy of the Library of Congress*)

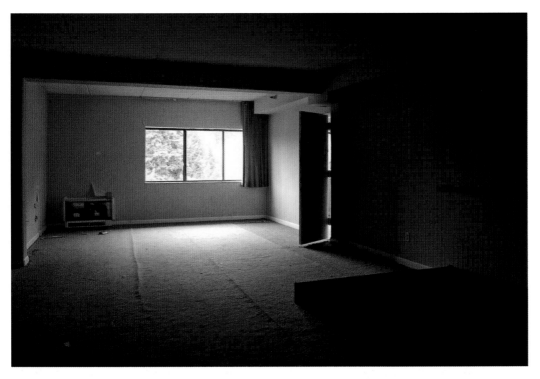

A guestroom as it stood after decades of vacancy. This singular chamber escaped much of the decay that befell its neighbors.

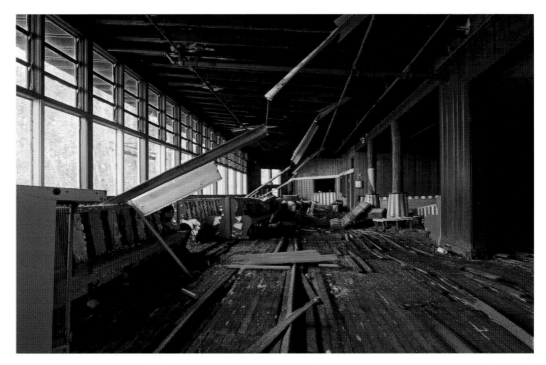

Years ago, an ice-skating rink existed just outside the windows of this lodge. It had overgrown so thickly through the years that one would never have known it ever existed if not for this building.

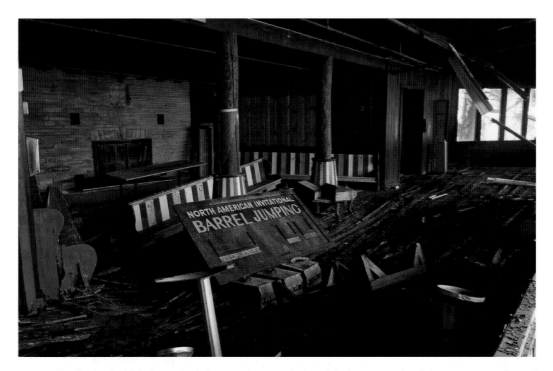

The flooring had failed completely in most places, and where it had not, even the slightest pressure splintered the wood. A sign for the barrel jump competition still survived, crookedly standing at the heart of the wooden implosion that was once the skating lodge and rental shop.

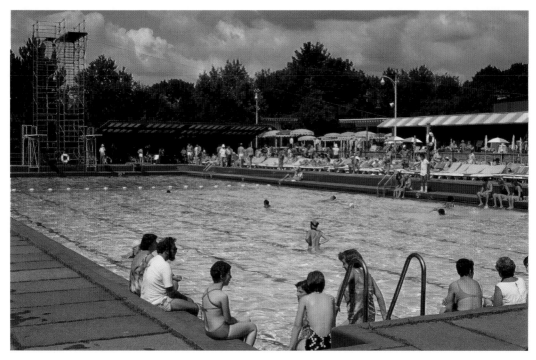

Grossinger's was famous for many things, but one of its most well-known features, and the thing that many vacationers arrived for, was the Olympic-sized outdoor pool. (*Photo by John Margolies, Courtesy of the Library of Congress*)

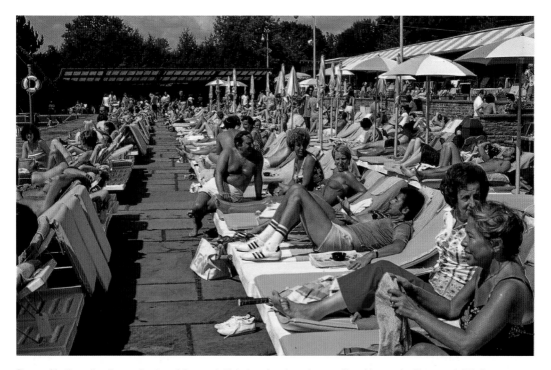

Rows of bathers line the perimeter of the pool. This is not a staged promotional image for the resort; this is a candid photograph taken in the 1970s that showcases the extent of Grossinger's popularity. (*Photo by John Margolies, Courtesy of the Library of Congress*)

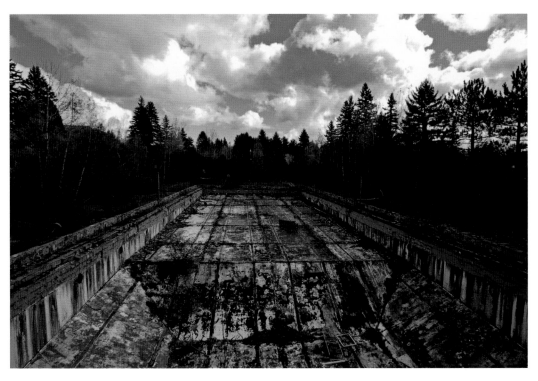

The pool, cracked and empty, as seen from atop the last remaining diving board.

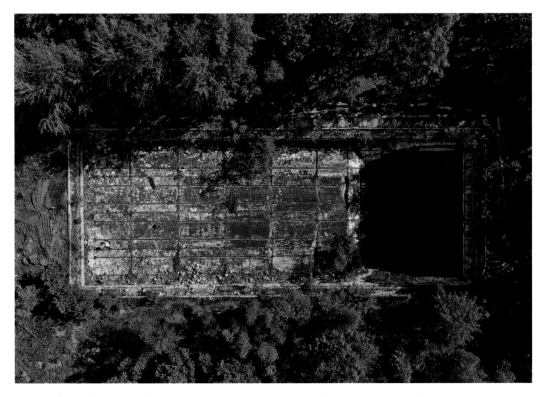

The pool from above. Where once rows of vacationers relaxed in the sun, patches of forest now grow.

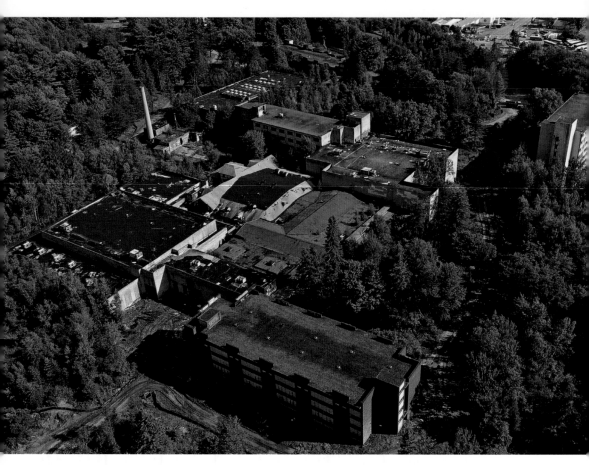

In the summer of 2018, demolition of Grossinger's began. In these aerial photographs from the early phases of work, you can see dirt inroads cleared through the grounds—pathways for the wrecking equipment.

A view from the town below, showing what Grossinger's looked like in its heyday and the extent of its spread across the mountain. (*Photo by John Margolies, Courtesy of the Library of Congress*)

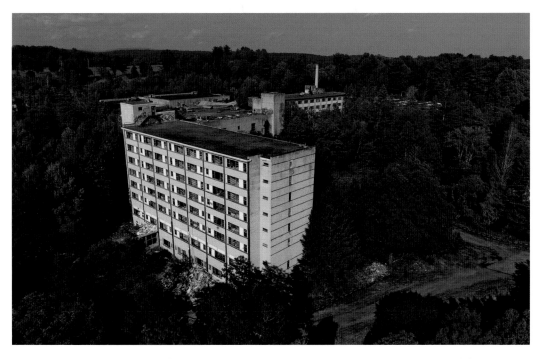

Early prep work being done for demolition. Outbuilding and smaller auxiliary structures had already been removed by this point; all that remained was the resort proper.

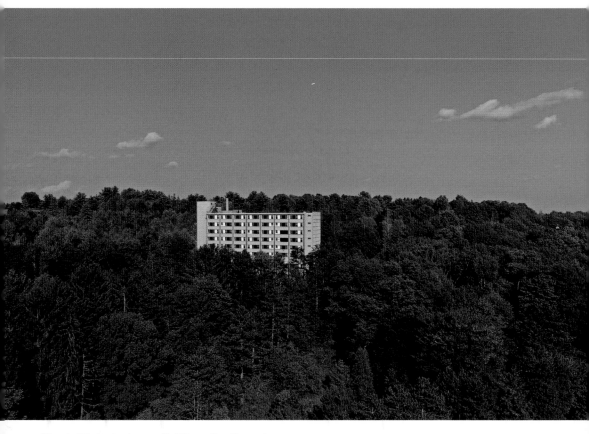

"Jennie G" stands alone on its hill, awaiting the end.

5

THE UNION HOTEL

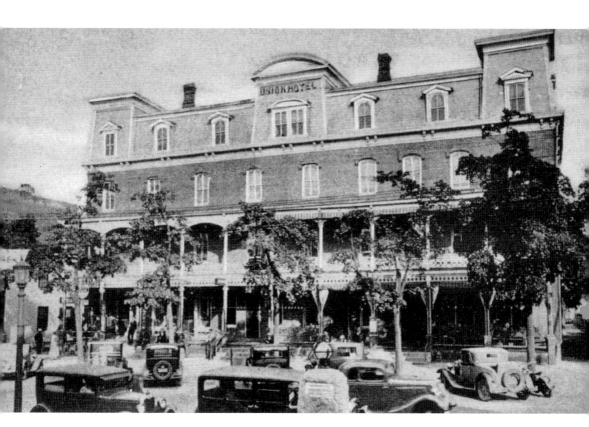

The Union Hotel has a complex history. What may appear to simply be a historic inn, positioned in the heart of Flemington, New Jersey, is, in reality, a location of a notable historic significance and the epicenter of countless urban legends.

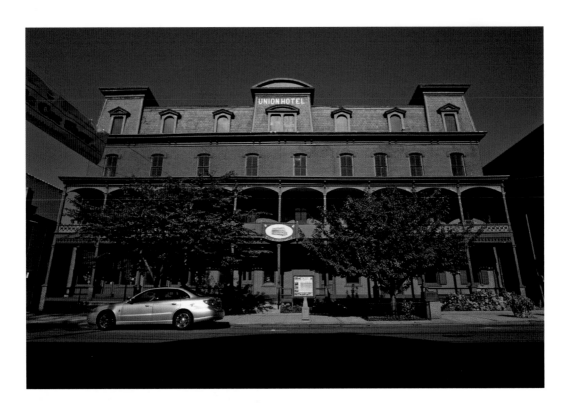

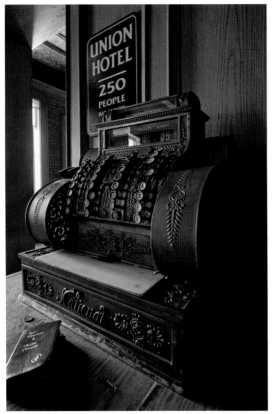

Above: Though the restaurant and pub that occupied the ground level of the hotel closed in 2006, the higher floors, which contained the guest rooms and amenities, were disused well over fifty years ago.

Left: An antique cash register resides upon the front desk, though it has been ages since anyone has checked in.

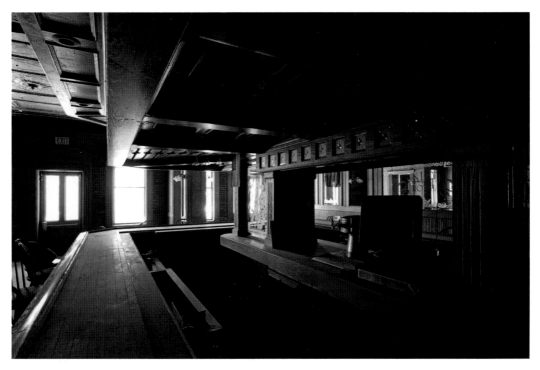

The lower-level bar, dusty but more or less as it was during operation. The same cannot be stated of the multiple floors that are housed above it.

It would be an understatement to say that the contrast between the ground floor and the upper levels is dramatic as they appear to be of different places altogether. It is an unnerving thought to envision these dismal rooms and hallways slowly eroding over the decades, directly over the heads of patrons dining and drinking below.

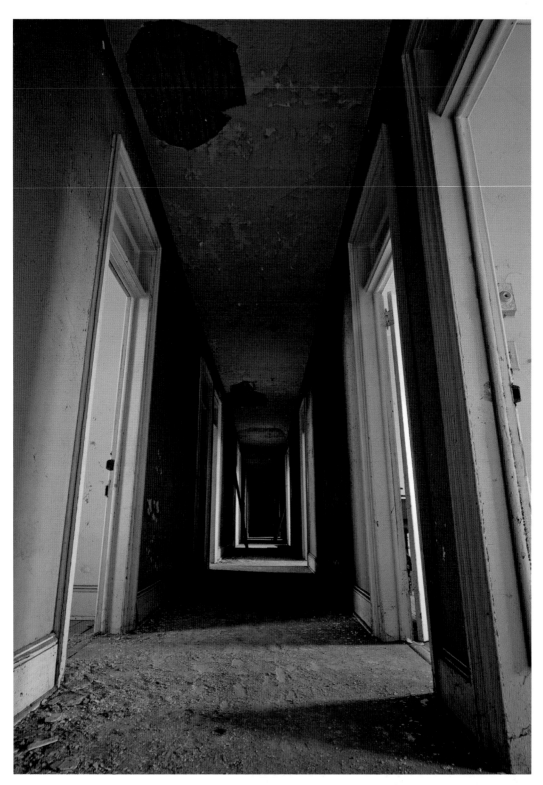

Understandably, the generations of vacancy have taken their toll, and large sections of the second and third floors are sinking further into decay with every passing year.

Right: The Union was not always so quiet; in fact, back in the 1930s, the hotel became quite famous when it found itself the temporary living quarters of journalists from all over the world as they covered the "Trial of the Century," breaking daily news of the Lindbergh kidnapping trial that unfolded across the street in the city courthouse.

Below: The trial found Bruno Hauptmann accused of abducting and murdering the son of famed aviator Charles Lindbergh. This photograph, which hung in the entry of the Union Hotel, shows just how overwhelming the crowds were during the height of the trial.

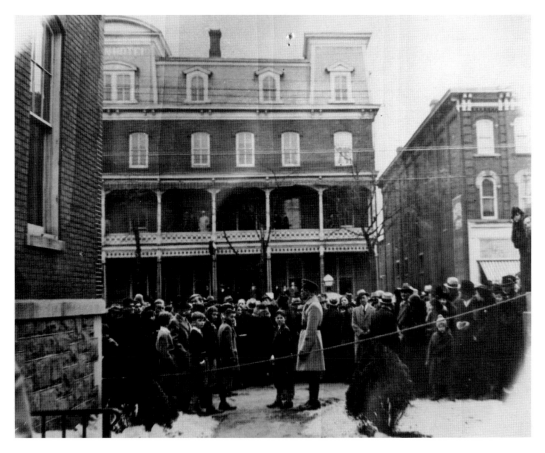

After five weeks of testimony, Bruno Hauptmann was found guilty of the charges brought against him. The conviction was not without controversy, however, as Hauptmann repeatedly professed to having been beaten to confess by the police and forced to give handwriting samples that matched the ransom note, which was presented as evidence. Hauptmann was executed via electric chair on April 3, 1936.

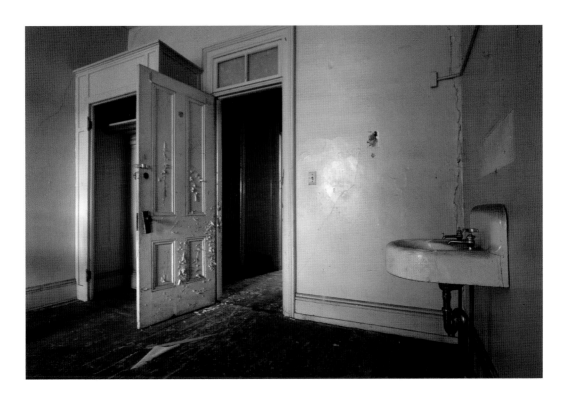

Above: Not surprisingly, the sordid tale that unfolded across the street left lasting impressions on the Union Hotel, and stories of strange goings-on became more and more prevalent as the years went on.

Right: Perhaps these stories are just a result of the hotel transitioning from a global current-events epicenter to the relatively sleepy establishment it had always been before the Lindbergh trial blew into town.

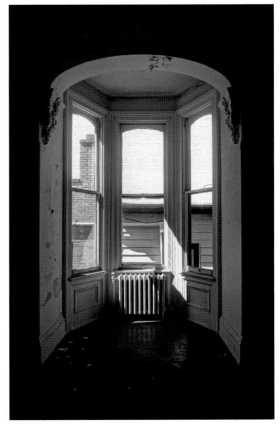

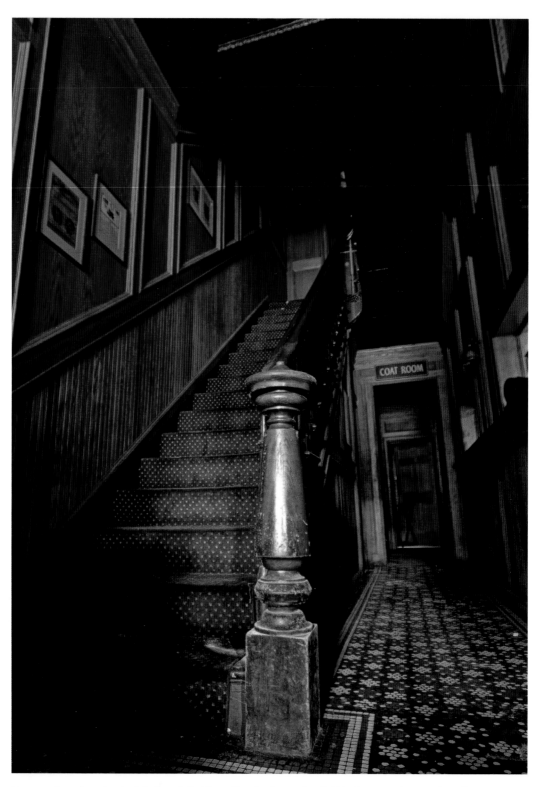

However, there is a singular tale though that is worthy of note—a story told by former patrons and employees alike, which involves the specter of a small girl who is frequently seen around the central stairwell.

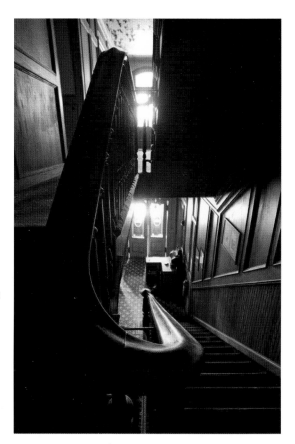

Right: Whether these stories stem from the real-life murdered Lindbergh baby is unknown. Some claim it to be the spirit of the murdered Lindbergh child, as the boy was so young at the age of his passing that he could easily be mistaken for a girl of the same age.

Below: Deer stare out from a mural painted on a wall of the former dining hall—obscure now, as shadows and quietness have replaced the brightness and chatter of decades passed.

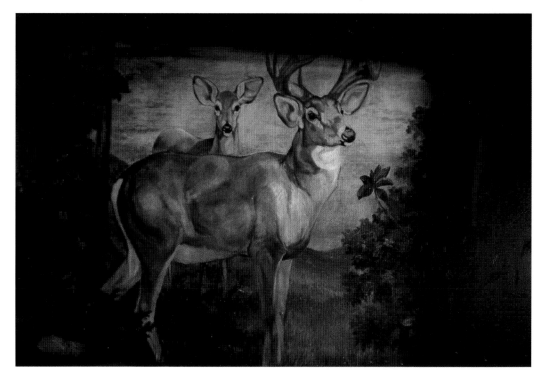

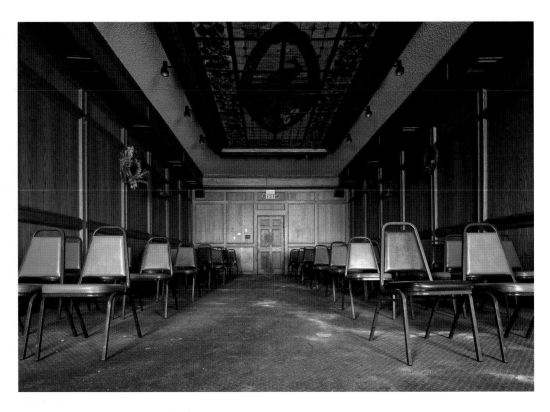

Above: A former meeting room with chairs yet aligned in rows.

Left: If spirits do indeed dwell here, their existence is likely a lonely one. After numerous failed renovation plans, the Union Hotel remains as empty as it did when it shuttered in 2006.

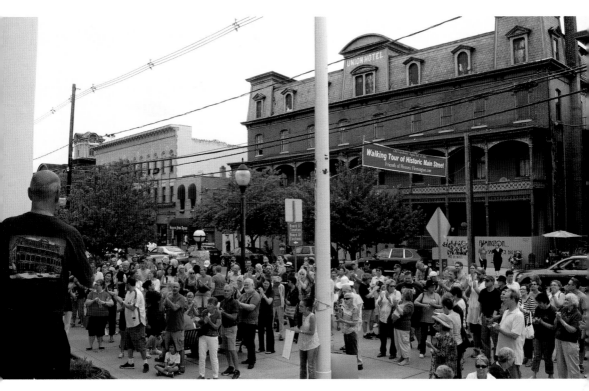

The hotel may well exist in an abandoned state, but that does not mean it is forgotten. When developers threatened to demolish the building to make way for a redeveloped main street, a rally was held on the steps of the courthouse across the road. People came in droves to support the preservation of the old hotel—a valued piece of antiquity that had come to be an important fixture to the town of Flemington.

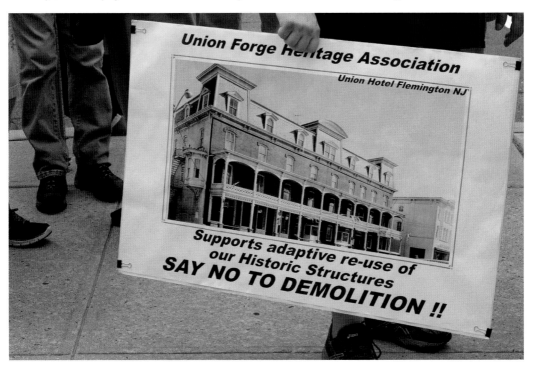

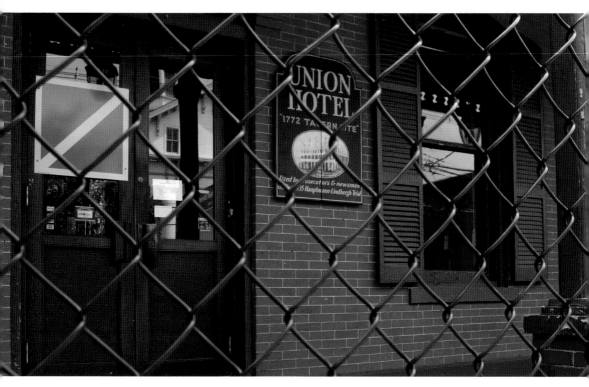

Thanks to the efforts of preservationists, the Union Hotel was spared the wrecking ball. Now, instead of being razed in favor of new construction, plans call for its adaptive reuse. Hopefully, one day, travelers will be able to visit the Union Hotel, as many had throughout the century and a half that it has stood. Until then, it endures in silence behind a chain-link fence.

6

NEVELE GRANDE

Lost places, like the Nevele Grande resort, stand as unique objects of fascination for many reasons. Oftentimes, it is because these locations have come to exist in a state contrary to their constructed roles. In this case, we may find initial captivation in the absolute silence where thousands once gathered with their families. Beyond that, there is something arguably more profound that ties all these places together, a common thread that entwines every abandoned structure and property—time.

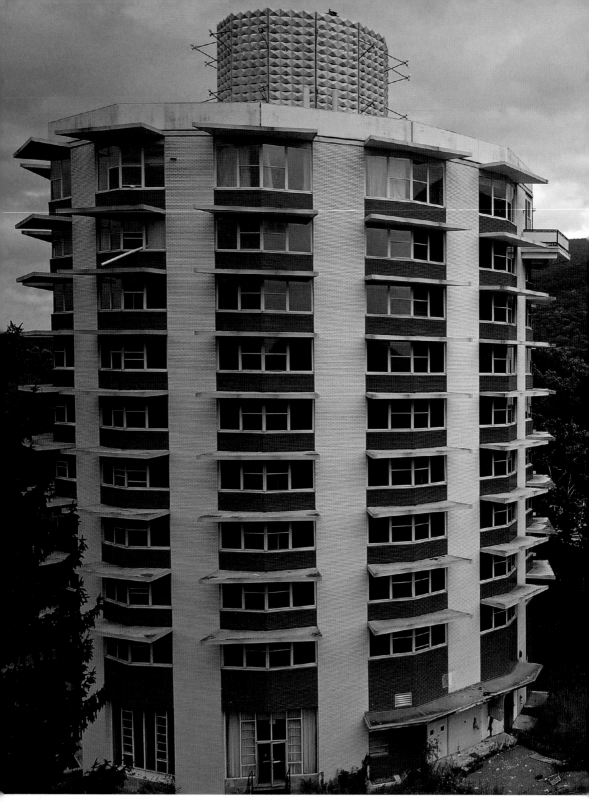

Human history, all history really, crests and recedes like the waterline along the shore. Popular culture rises and falls, profitability rises and falls, communities rise and fall, and nations rise and fall. The waters of time endlessly

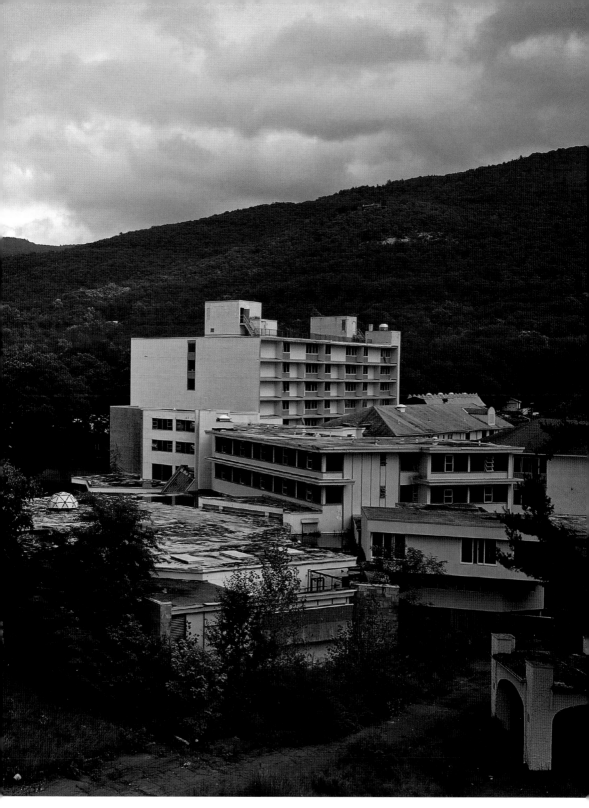

surge and recede, and after the tide has withdrawn, these places remain in the wake, like cast-off shells upon a beach. They are massive artifacts of eras past, tangible memories of stone and steel.

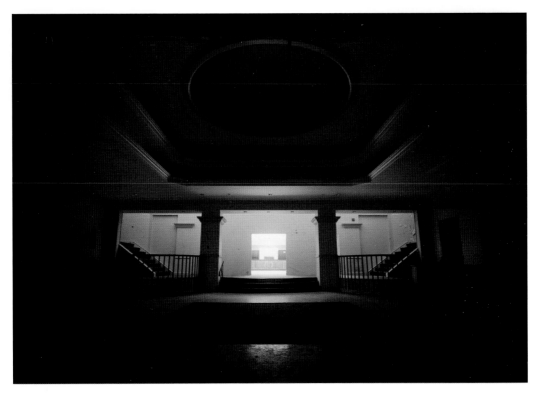

The cavernous lobby, as full of echoes and it is of stories.

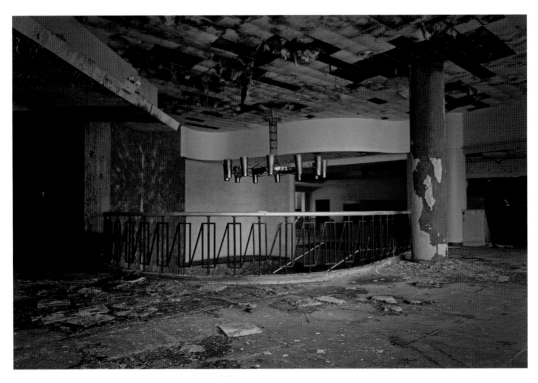

A chandelier hangs over the central stairwell, watching the resort around it slowly rot away.

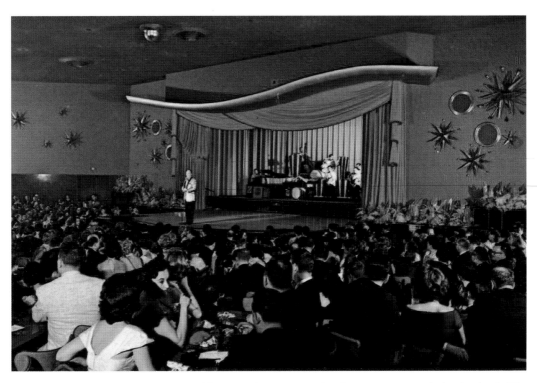

The "Stardust Room," a lounge and live-entertainment venue that, in many ways, was the beating heart of the resort. It is lifeless now.

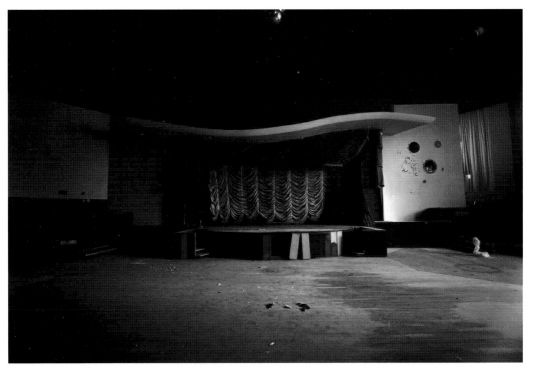

Glamor and crowds become tatters and dust.

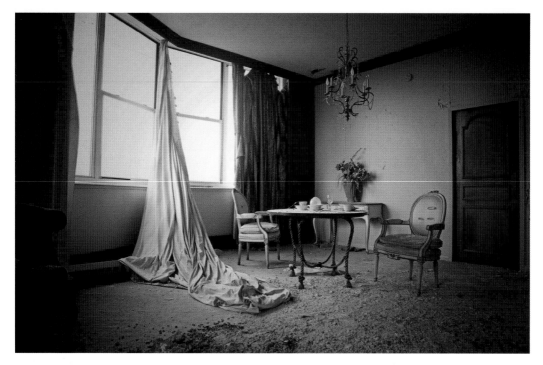

The tower building of the Nevele Grande stands ten stories tall, and on the uppermost floor once existed an exquisitely outfitted penthouse. Now the rot has deeply rooted, and what was once a beautiful suite has come to be merely a sad reminder of some past event.

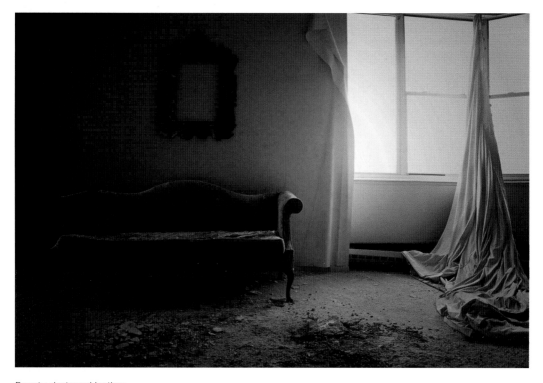

Beauty, destroyed by time.

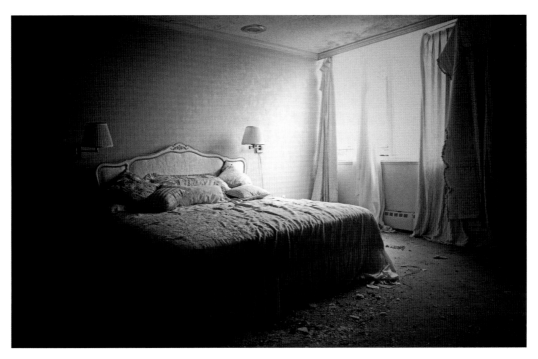

The earliest buildings on these grounds opened to the public in 1903, with much of what is currently standing dating from the 1950s and '60s, including the distinctive tower structure which looms high above all else. By the time the resort was closed, it had served the region for over a century.

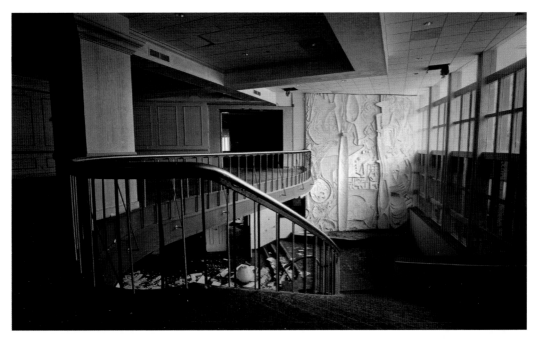

Acknowledging the long lifespan of the old resort makes the grounds today all the more melancholy. Generations of families vacationed here—parents bringing their children, just as their parents had brought them. There is no doubt that the stillness that now embraces this property is steeped with memories of those who knew it in more joyful times.

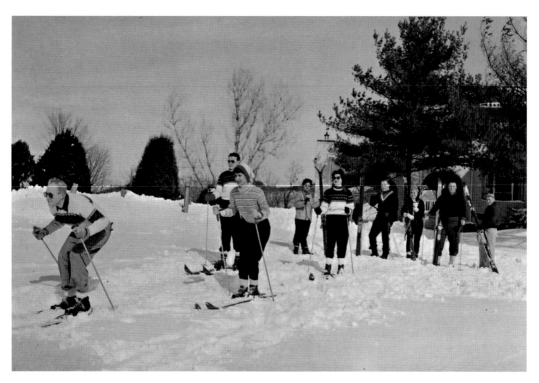

A postcard showing a group of skiers. Though often billed as a summer resort, there were no shortage of families who visited the Nevele in winter for seasonal activities, specifically skiing and ice-skating.

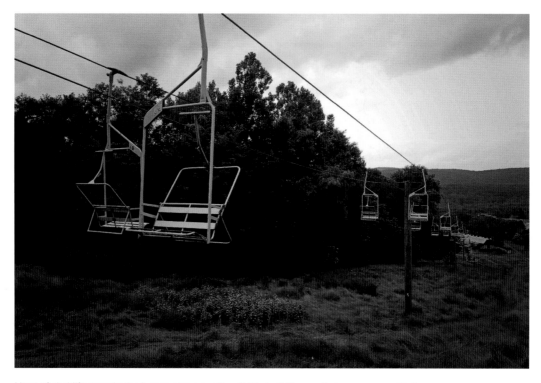

Lines of chairlifts sway in the breeze above a rolling field of wildflowers that was once a ski slope.

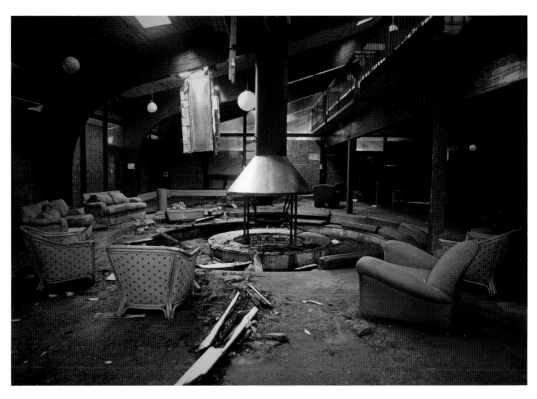

The former ski lodge, complete with central fire pit. In its prime, this was a wintertime hub for the area.

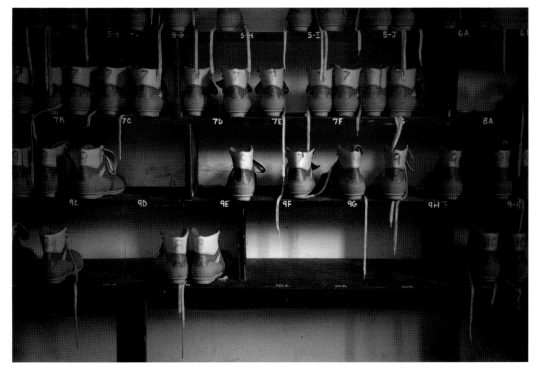

Rows of grimy rental boots line the shelves.

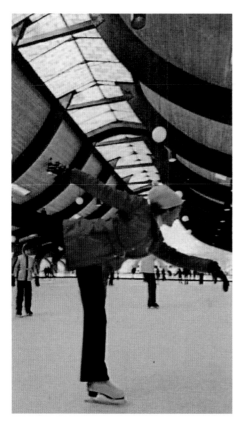

Left: A postcard image of a young woman figure-skating upon the ice rink at the Nevele.

Below: Today. the rink is a pitiful sight to see. Though, sad as it is, it is fairly easy to imagine the place as it were—music, lights, and laughter. It is all still here, hidden just below the surface.

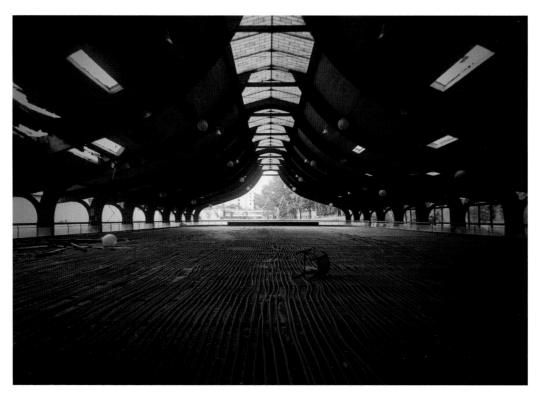

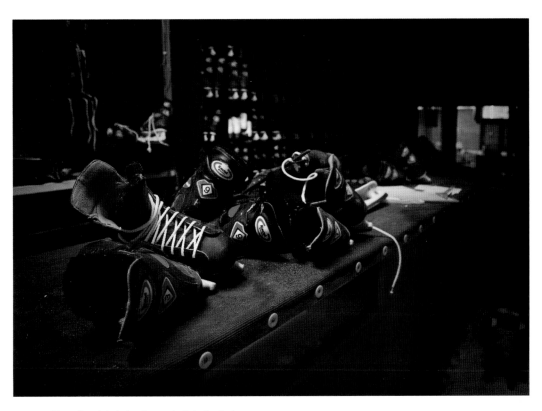

Piles of rental skates line a desk in the lodge.

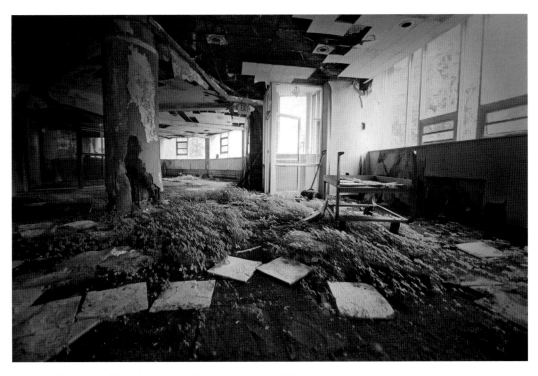

A tiny forest of ferns grows upon the sodden carpet of the hotel lobby.

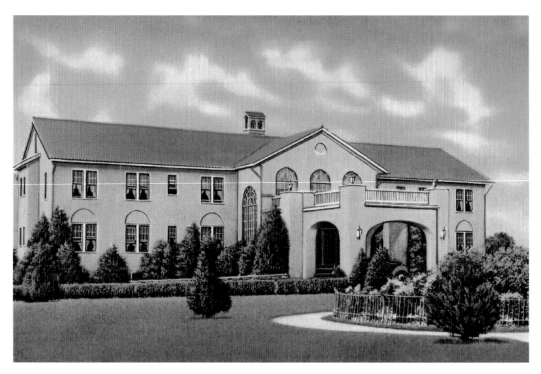

Though much of the grounds were updated in the '50s and onward, this humble structure, one of the original buildings of the resort, survives to this day. Once used as lodging, later in its life, it was repurposed to a form of staff housing before shuttering for good in 2009.

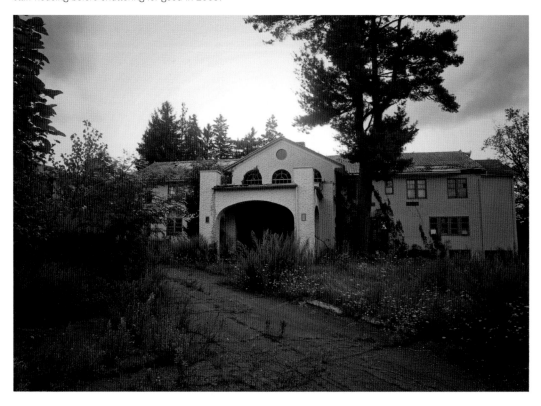

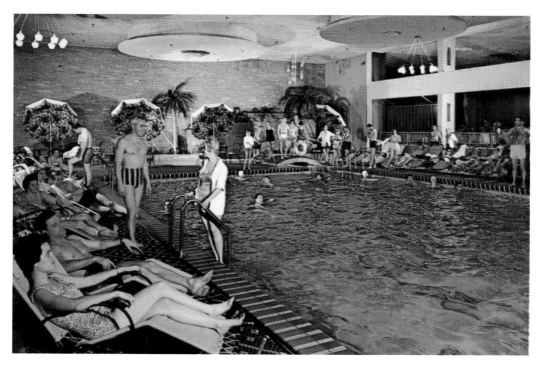

The indoor pool at the Nevele was a popular feature up until the end. Regrettably, like many resorts of this time, the relentless push to "modernize" and update found many of the wonderful vintage fixtures removed and replaced by far simpler (and far more boring) recessed lighting and minimalist designs.

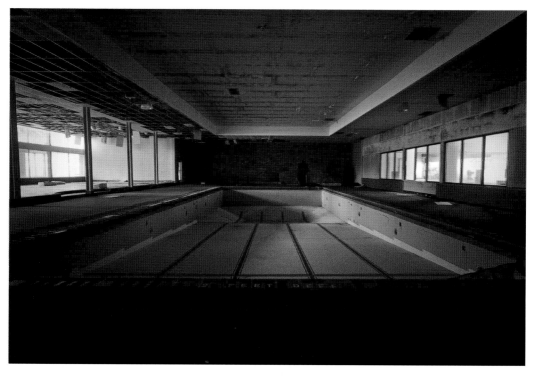

The pool today, far less adorned than in its heyday.

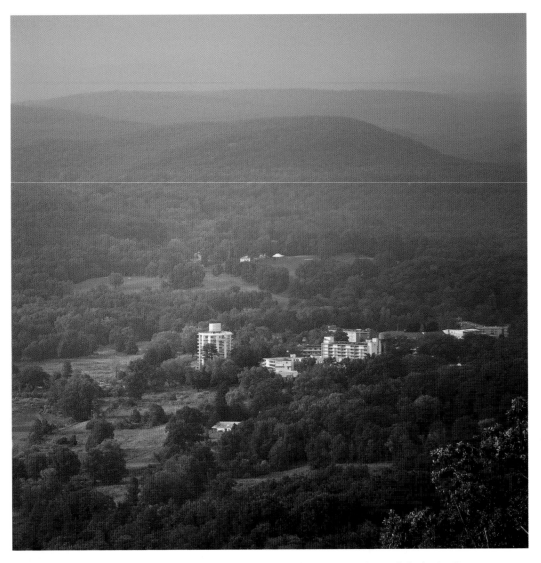

The Nevele Grande huddled into its wooded valley. Toward the distance, a storm front rolls in, hazing the outlying peaks in a grey mist.

Scan the QR code or visit bit.ly/NeveleGrandeVideo for an exclusive video.

7

PINES HOTEL

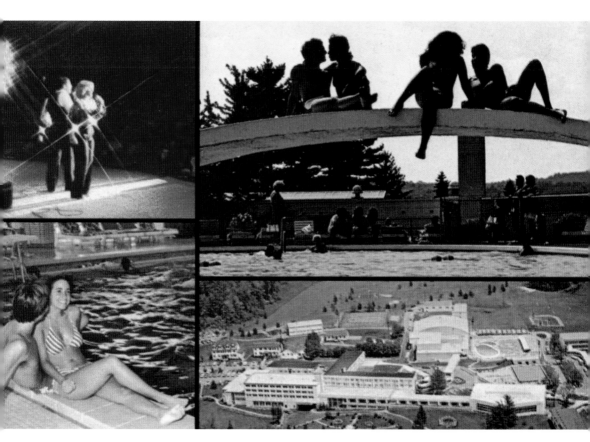

Once upon a time, the Pines Hotel was a one-stop vacation destination. With swimming, live shows, fine dining, golf, skiing, and hiking, visitors would be hard-pressed to name an activity the Pines did not offer, and offer well.

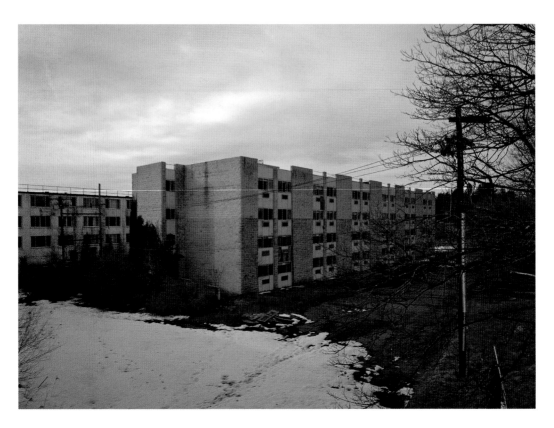

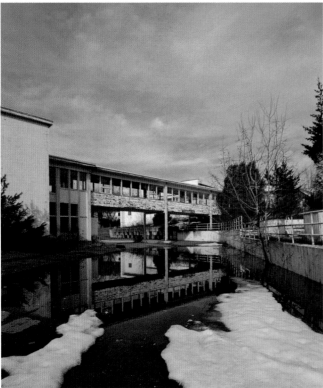

Following its closure, the Pines Hotel quickly fell by the wayside, forgotten by many, and quite literally abandoned by all. The resort exists today in a forgotten state, and it cloaks the property in a strange ambiance—a kind of oblivion between life and death where time moves differently than out in the greater world.

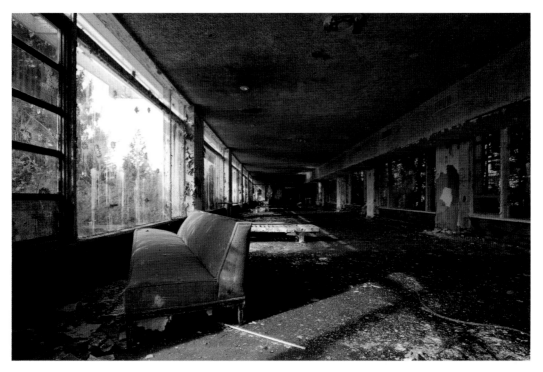

The aged resort wastes away, soaked with rain and cloaked in hues of green from moss and mold. Of all the resorts we have documented over the years, the Pines is by far the most soaked. Even amid hottest, driest summer, the resort always manages to be a mire of sludge and puddles within.

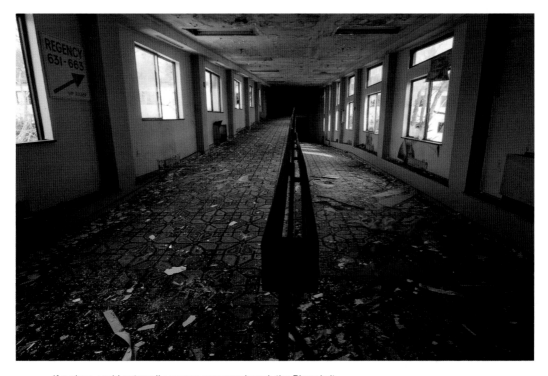

If a place could outwardly appear unremembered, the Pines is it.

While documenting the grounds, we came upon a man residing in an old trailer on the property. After introducing ourselves, we quickly struck up a conversation. Through a series of misfortunes, the gentleman had found himself without a home and decided to take refuge on the grounds of the old resort—a place he knew well from his youth.

He told us that in his younger years, he had worked at the Pines, and though he performed various tasks at the hotel, his most fond memories were of working at this check-in desk located in the lower-floor lobby.

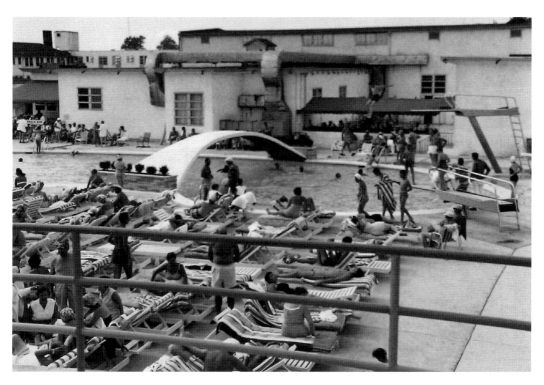

The man also shared with us several old photographs that he had found discarded around the resort grounds. This one shows the outdoor pool during a far more joyful state.

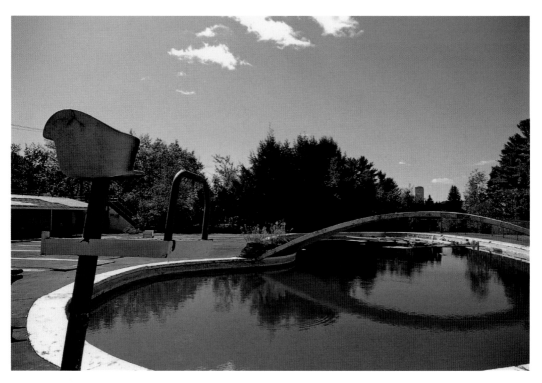

The pool today, faded and stagnant.

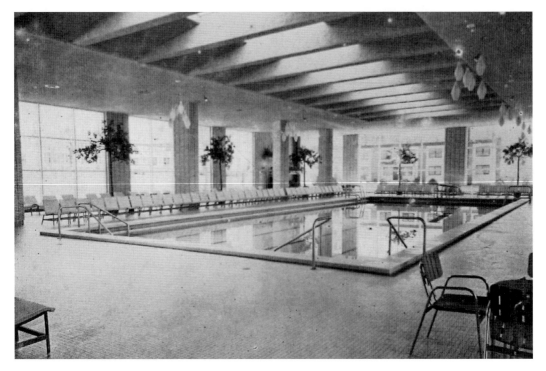

Another old photograph, this time showing the indoor pool, shared with us by the man now living just a few hundred feet from it.

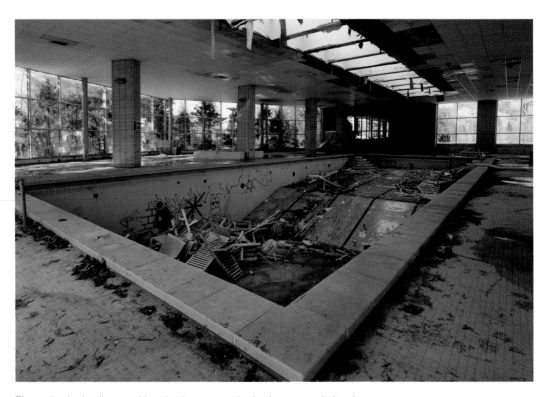

The pool today hardly resembles what it once was, having become an indoor bog.

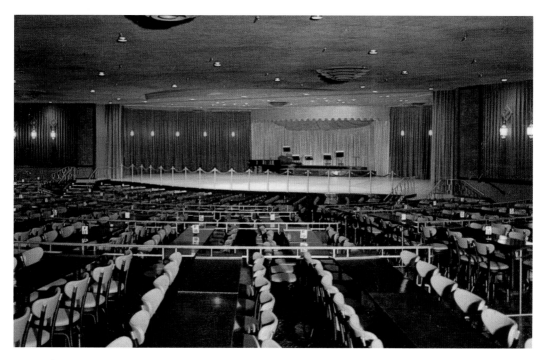

Pools aside, the Pines offered many other attractions, and one of the most impressive had to be the huge showroom. Known as the "Persian Room," performers such as Buddy Hackett, Robert Goulet, and Tito Puente once entertained from this stage.

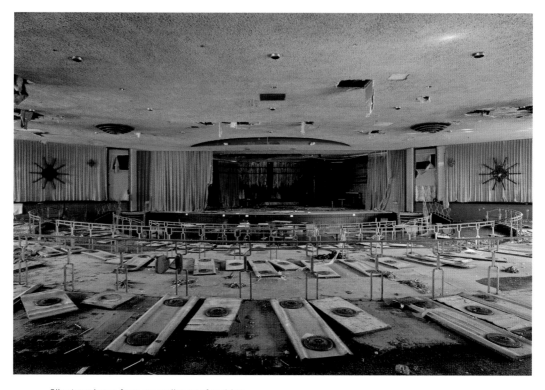

Silent applause from an audience of nothing.

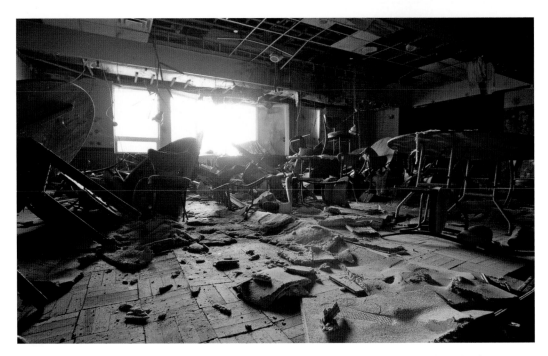

The resort managed to make a real name for itself not only through the quality of its live entertainers but from its legendary food and dining hall. At one time, aromas wafted from these kitchens, and the clamoring of guests enjoying themselves and their meals could be heard across the property. That was long ago though. Today, these same tables are toppled upon waterlogged floors, and all that lingers in the air is the pungent stench of rotting wood and moldering carpet.

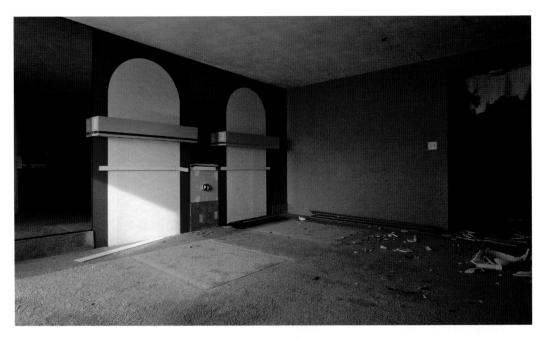

Now and then, you may come upon an area that has escaped the decay of the resort that surrounds it. In these preserved spaces, it becomes far easier to know the resort as something other than the drowning, defeated mess it has come to be.

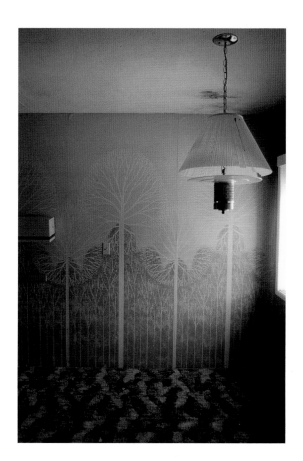

Right: Recollections of generations linger here, with dust and outdated decor.

Below: Perpetually wet and cold, the resort disintegrates. With every passing year, its frame grows weaker, the holes in its roof larger, and its time on earth shorter.

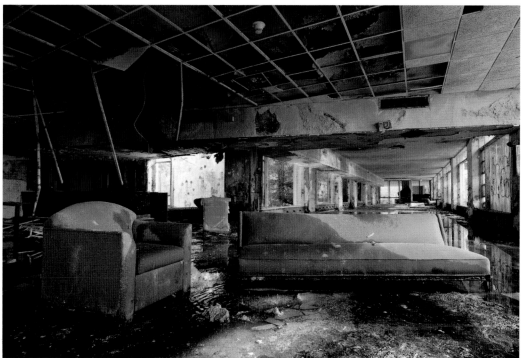

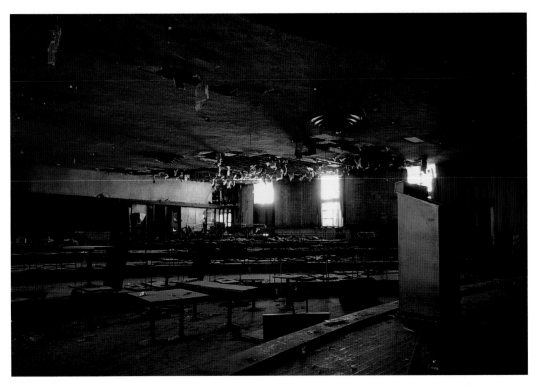

View of the "Persian Room" from the theater stage.

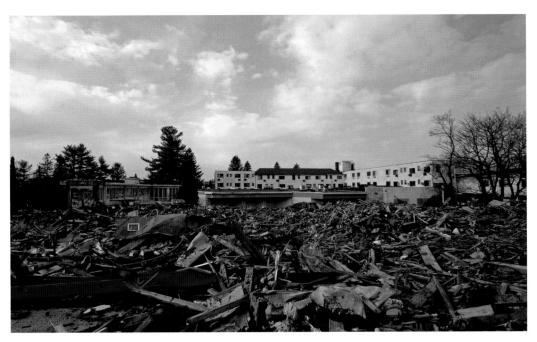

Today, all that exists of the grand theater is a pile of rubble. Seemingly indiscriminate demolition of portions of the Pines Hotel claim the property just as fast as the widespread decay. Gone too is the man from the trailer, with his insight and anecdotes about a place many no longer remember. With his departure, so too leaves the final bit of life from the Pines Hotel.

8

HOTEL COLUMBIA

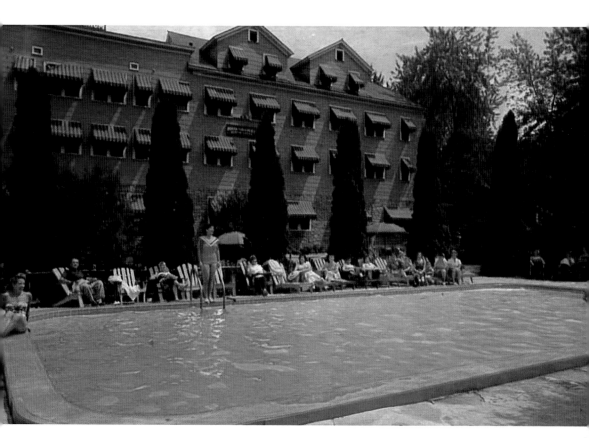

The Hotel Columbia came into popularity in the early 1950s, serving as farther-flung destination hotel and resort, well over an hour's drive outside the main tract of the Catskills resorts of the day. Also unlike many of the properties featured thus far, the Columbia was a singular building surrounded by little property—just enough room for a sidewalk and modest pool.

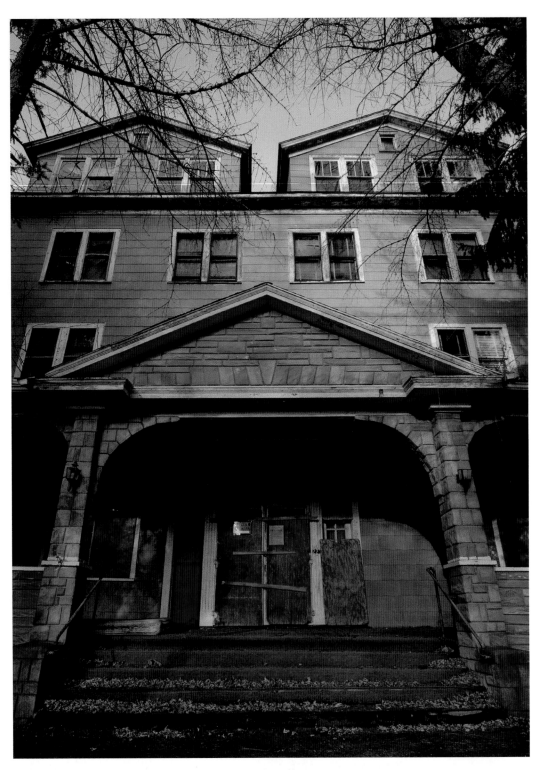

The hotel closed for good in 2004, and today, large unmaintained pines all but overwhelm the front of the building. Without prior knowledge of its existence, one could very well drive right past it on the town's main throughway, just half a block away, having not the slightest clue that you completely overlooked a deserted four-story tall building.

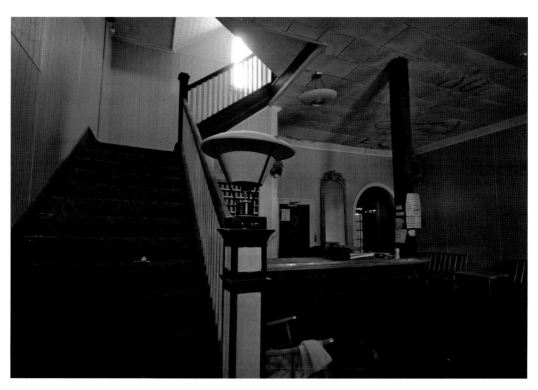

The entry of the Columbia stands in an eerie nonexistence, bathed in unusual hues cast by the bedsheets that cover many of the windows.

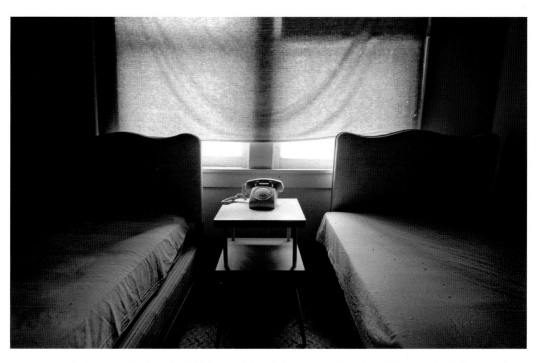

Many bedrooms and beds are in slight disarray; it is as if whoever stayed here had left the room just before we entered.

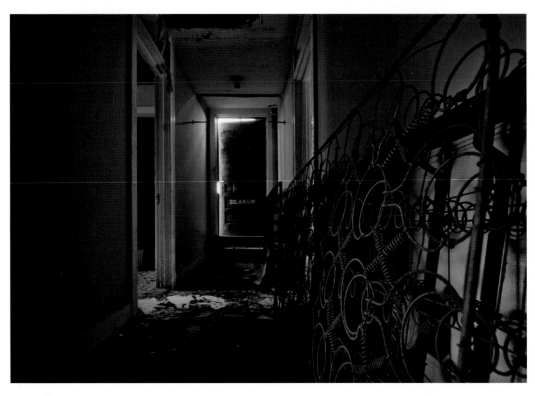

Inky shadows have come to reside here; at times, the darkness seemed almost suffocating to wade through.

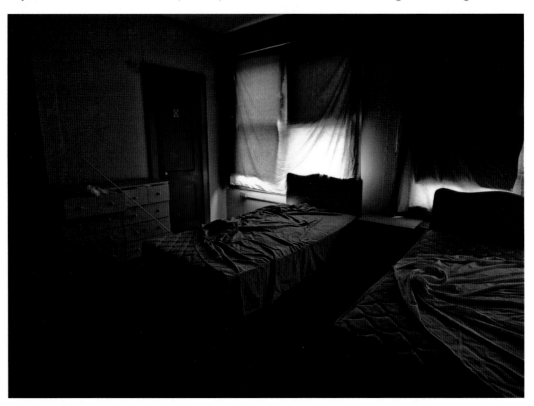

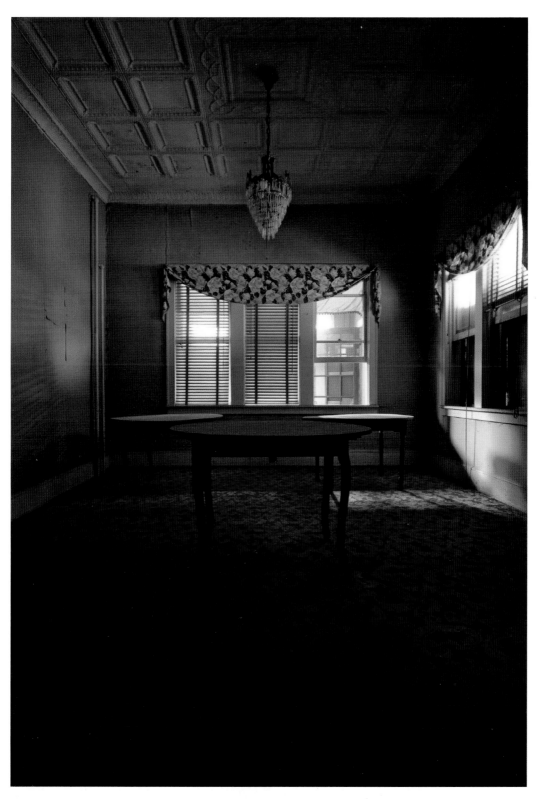

The former dining hall, dim and lifeless, yet at the same time seeming like guests could walk in at any moment.

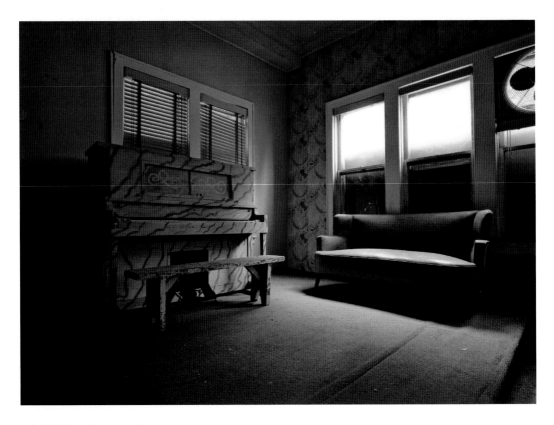

Above: An upright piano resides upon a small stage in the former hotel lounge.

Left: A detail of the wallpaper pattern in the lounge, haunting as it is.

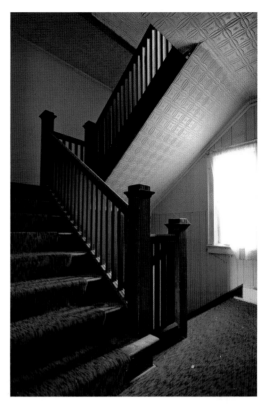

Right: Vintage carpet and tin ceilings; flaking paint and spider's webs.

Below: Renting a room here actually gave guests two—one bedroom and a room across the hall that contained a small kitchen and dining area. From the looks of things, these kitchen-rooms were an after-thought, remodeled from excess bedrooms that the resort no longer had a use for.

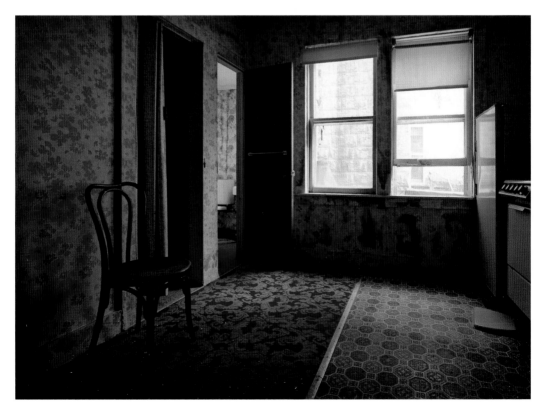

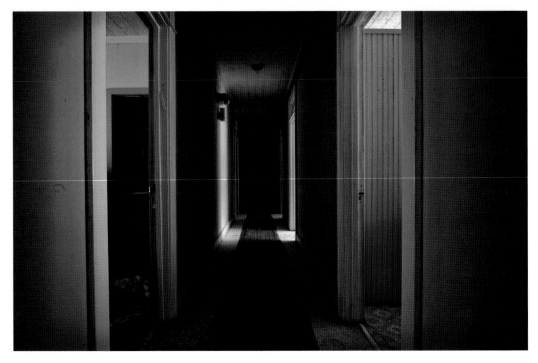

Though the condition of the building appeared quite sound overall, one wing in particular suffers very badly from water damage. The floors here creak and snap when walked upon. Hidden away below vintage carpeting and wooden floorboards, the core of the hotel grows weary and frail.

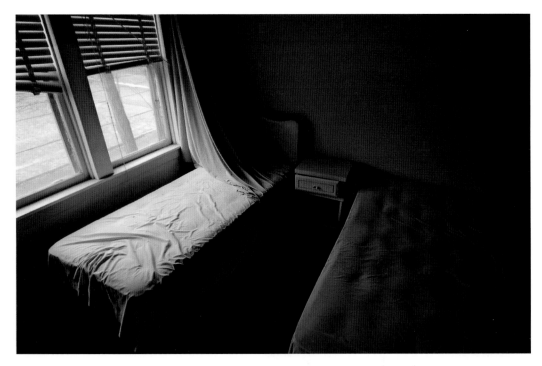

As is the case with most lifeless things, this place is cold. Old windows and the occasional absent pane of glass provide the biting winds of winter an easy entry.

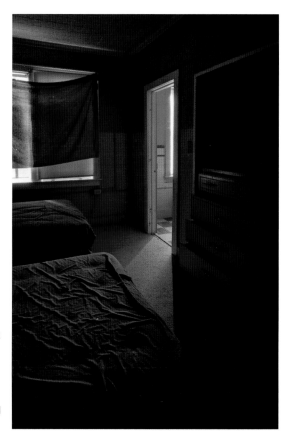

Right: Orange sheets hang on windows, casting a beam of deep amber through a dark bedroom.

Below: Though just a singular building, it is easy to forget how extensive the Columbia is. This is a view from the third floor, gazing toward the peeling façade of the opposing wing.

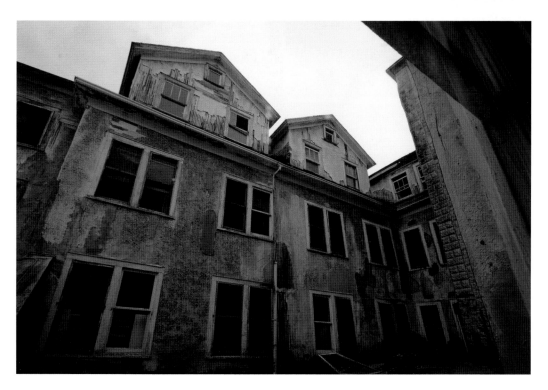

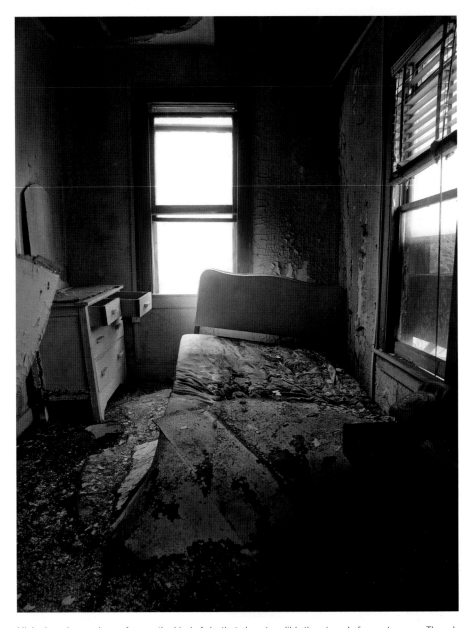

High above hung a haze of grey—the kind of sky that almost audibly threatened of snow to come. Though a true storm never manifested itself, light flurries eventually began to fall. They floated down from the sky as flurries always do, randomly tumbling in unpredictable ways, very slowly changing the landscape as they cover everything in a dusting of white. Occasionally, a flake would manage to enter in through an open window, to settle upon a bed or nearby nightstand, remaining there only a brief moment before dissolving.

Scan the QR code or visit bit.ly/HotelColumbiaVideo for an exclusive vide.

9

HOMOWACK LODGE

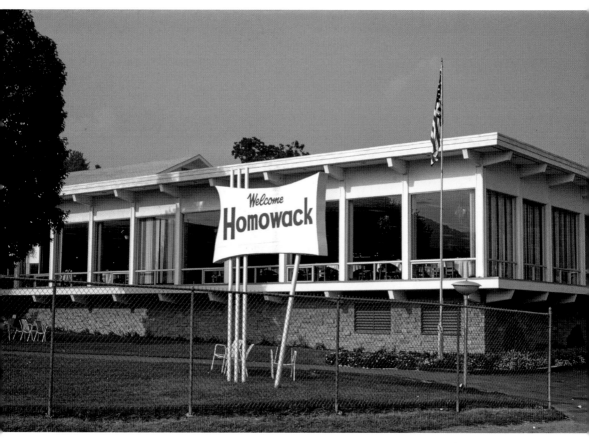

The rise and fall of the Homowack Lodge mirrors many of the other resorts that once dotted the Catskill Mountains. In its prime, the grounds served hundreds of guests at a time, but what was formerly a thriving resort has ended its life as a dilapidated collection of buildings condemned by the state of New York. (*Photo by John Margolies, Courtesy of the Library of Congress*)

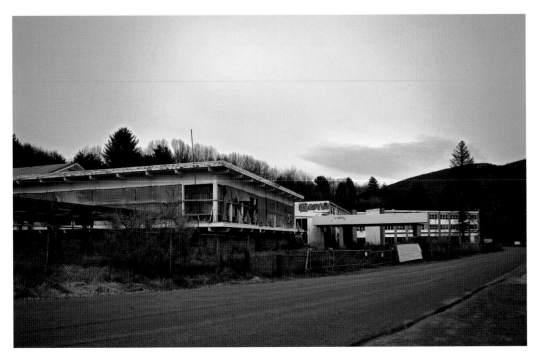

What makes this tired old property so interesting is that unlike many of the other locations highlighted in this book, these buildings have suffered chiefly through human hands. Vandalism, theft, and the scrapping of valuable materials has left the resort in a ruinous state—similar but also quite a different destruction than that of the slow and tenacious decay brought on by nature.

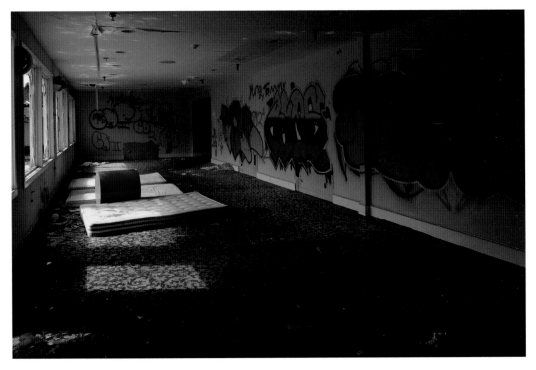

Dark and murky but punctuated throughout by bright patches of graffiti.

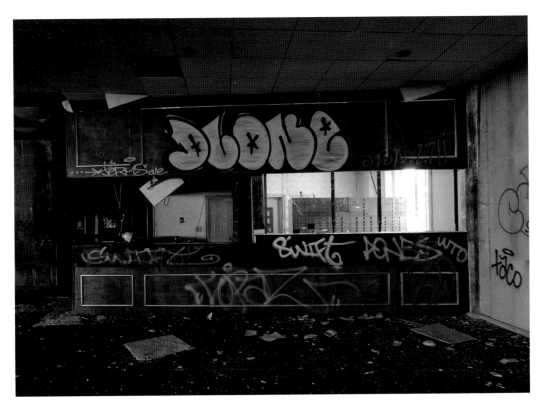

The check-in counter, almost unrecognizable.

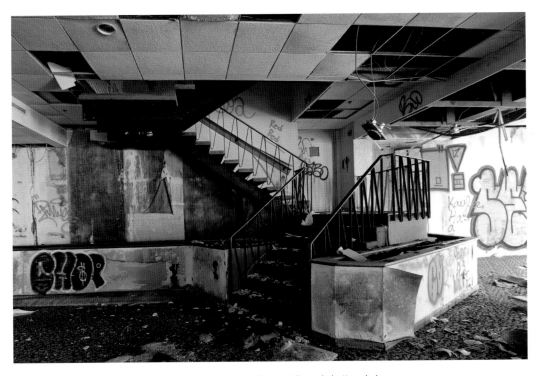

A lobby staircase, leading upward to corridors of torn walls and shattered glass.

Leaves blow down an upper hallway. Though evidence of human activity was everywhere, the silence was still haunting at times.

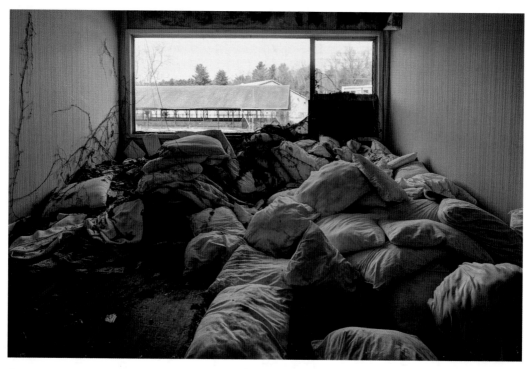

A room of pillows rots under a broken bay window.

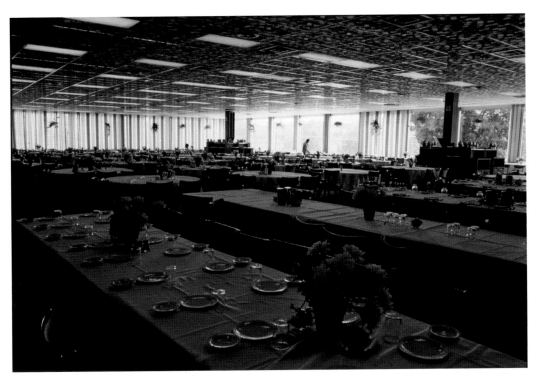

The late dining hall, created to seat hundreds of families, now strewn with broken glass and fallen structure. Water pools in the center of the room, reflecting the rotten ceiling above. (*Top photo by John Margolies, Courtesy of the Library of Congress*)

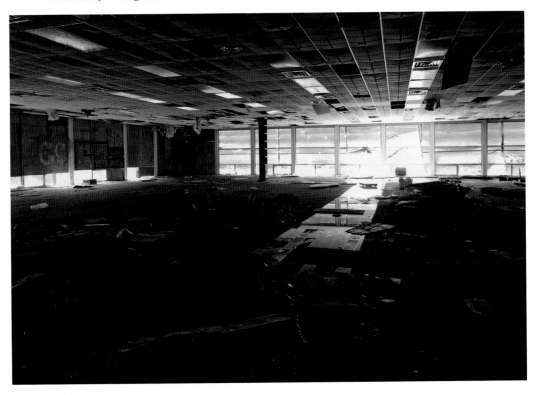

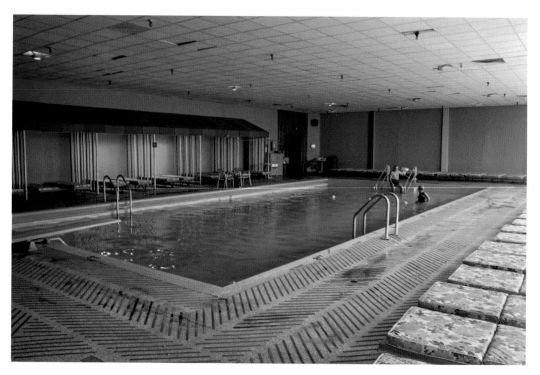

The indoor pool at the Homowack Lodge, as it was in the 1970s. (*Photo by John Margolies, Courtesy of the Library of Congress*)

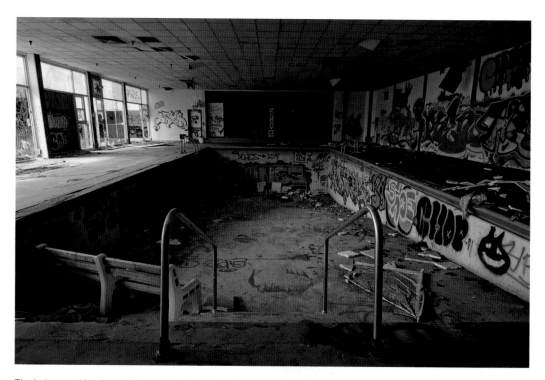

The indoor pool has been hit especially hard by graffiti artists after the closure of the resort—no longer a pool at all really, rather a concrete and stucco canvas for travelers to paint and repaint over the years.

A postcard image of the small bowling alley that once occupied the basement of the resort.

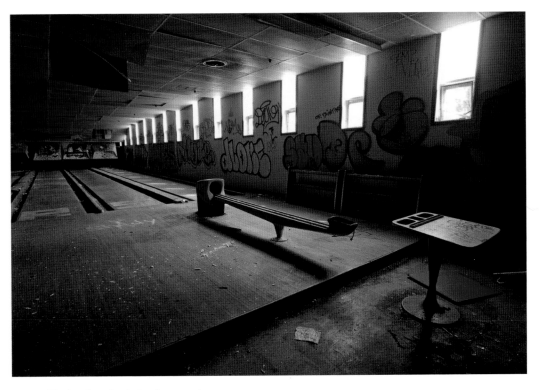

The bowling alley today, far worse for wear.

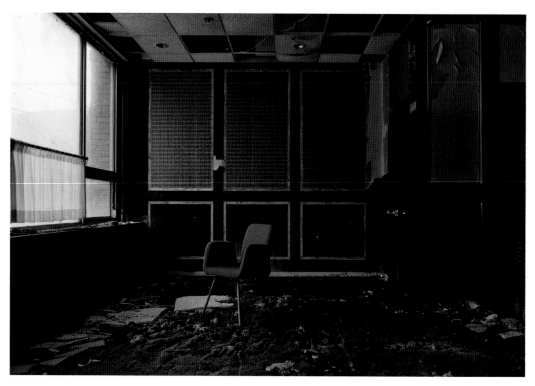

A chair sits alone in the corner of a dining hall as moss slowly encircles it.

Though vandalism and decay run rampant at the Homowack, the property is rather large and the destruction has yet to ravage it entirely. Away, hidden in some remote corners, there are still guest rooms decorated with linens and curtains—flickers of the resort's past life that seem wholly removed from the carnage just down the halls.

10

RESTORING THE DIVINE LORRAINE

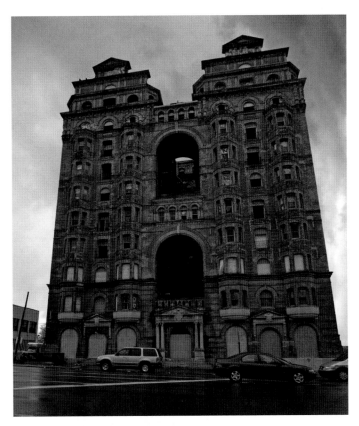

Prominently located at the crossing of North Broad Street and Fairmount Avenue in Philadelphia, Pennsylvania, stands the Divine Lorraine Hotel. A fixture of the community for over a hundred years, this building had come to symbolize a great many things—from its physical capacity as a monument of old Philadelphia, designed by architect Willis G. Hale, to the great strides in racial integration made by the Universal Peace Movement, led by father Divine, who acquired the property in the late 1940s. However, upon our visit in late 2011, the Divine Lorraine sat abandoned, gutted, and disgraced—an inappropriate end to such a beautiful and meaningful landmark.

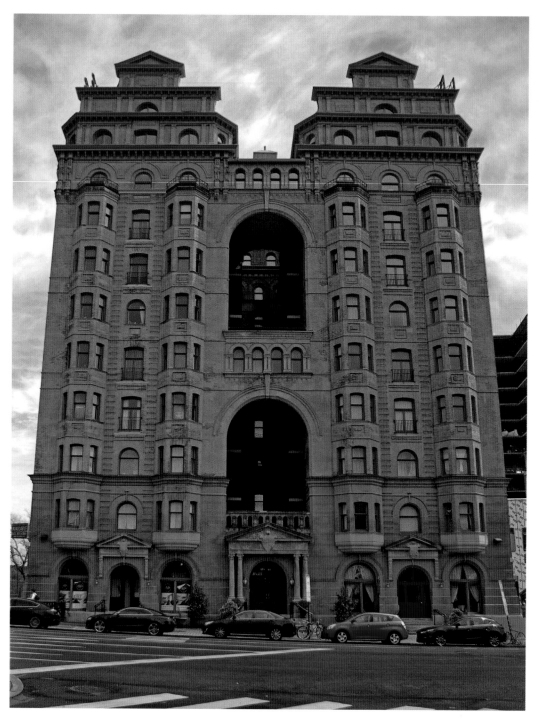

This chapter is not about endings though; it is about new beginnings, about returning dignity to a structure many regarded as lost and the rippling impact such endeavors send through the community when a piece of antiquity is protected, restored, and honored as it should be. It is about returning a piece of a city that had been missing for decades. Ed Casella, regional property manager for EB Realty, the company behind the preservation and reopening of the Divine Lorraine, expounds upon the monumental task of pulling the Divine Lorraine out from the limbo it had fallen into: "Our company believes that buildings have stories, and the Divine Lorraine's story was far from over."

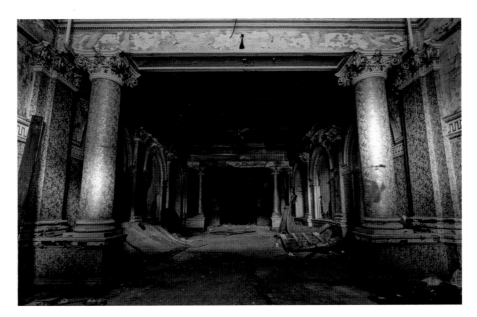

The former hotel lobby, baroque in its disarray. When the building first opened in its original role as a residence building, then known as the Lorraine Apartments, this room served as the grand entryway into what was one of the premier housing buildings in the city at the time. Specifically catering to the more affluent citizens of the city, the Lorraine Apartments boasted an in-house staff as well as electricity in all suites; it quickly made a name for itself through its luxurious amenities and the fact that it was one of the very earliest high-rises in all of the city. Upon our visit, that all seemed a lifetime ago, and it was.

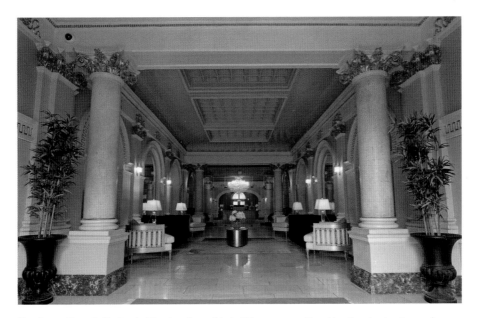

Casella continued, "Instead of tearing down this hulking mass on the side of main street, our aim was to restore it to its former grandeur." The lobby alone took over a year to rehabilitate, a task Mr. Casella and his company are understandably proud of. "It's 95 percent original, all the floor tiles, everything. It took a long time to do, based on historical data and colors … It was actually the last piece of the building we finished, we had to find a plaster specialist to come in and work in what was essentially an active construction scene with people and multiple deliveries going through all day."

A view from an upper floor window taken in 2011, when the Divine Lorraine was in a sad state of decay. Graffiti, broken windows, and dangerous flooring made it almost impossible to consider that there were people out there who still had faith in the building, people who recognized the life and potential that remained, even long after everything and everyone had gone.

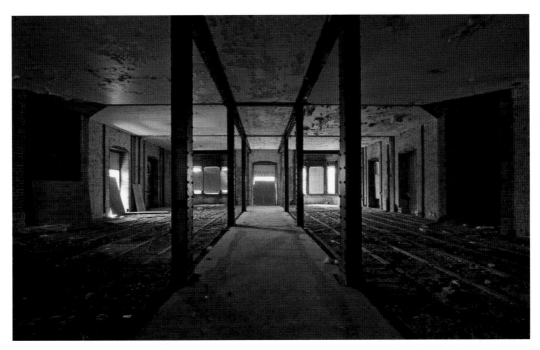

What the interior of the hotel looked like in the fall of 2011—gutted and discarded by a previous developer.

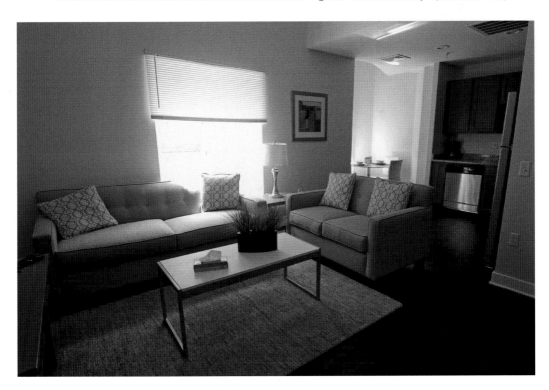

These once-barren floors now house life. The Divine Lorraine Hotel is once again serving in its original role as an apartment building. Intimate, personal histories are being made each day in a building already brimming with tales and stories from ages passed. "Our new rooms basically follow the same footprint as the original rooms did, but those old rooms were very small, so we made the new ones take up two or three of the small rooms which were once here."

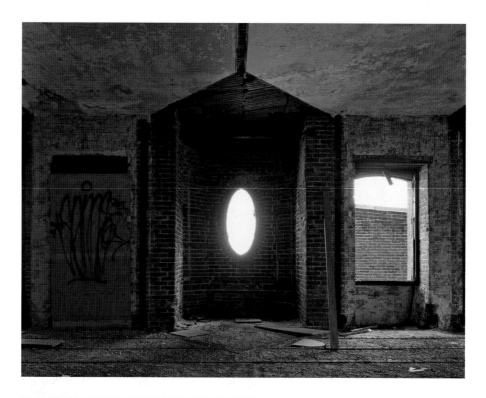

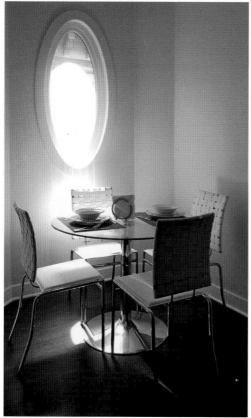

A kitchen nook sits under a porthole window. These oblong apertures are one of the visual elements that made the Divine Lorraine so unique and are a personal favorite of Ed Casella, "I love those windows. To sit there, to read the *Philadelphia Inquirer* and look out it at the city … like a lot of people must have through the years."

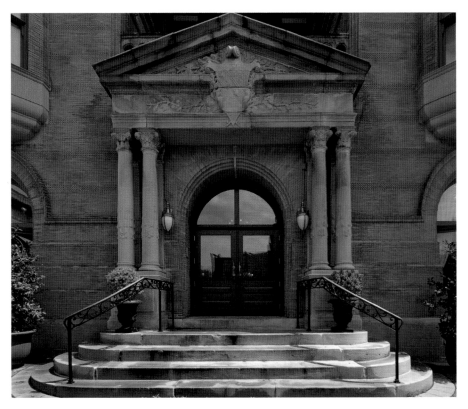

"We were able to put a face back on a building that everyone knew, everyone walked past, and no one in their right mind thought would be restored. Everyone thought it was going to be torn down, and we were adamant that was not going to be the case"

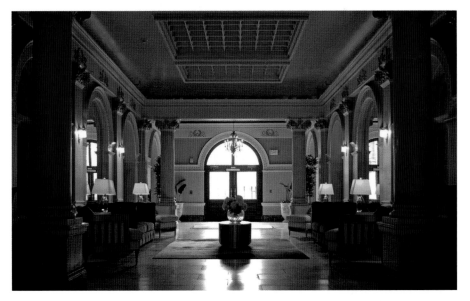

"I can't tell you how many people come in here, jaw open, and look around for fifteen or twenty minutes, telling us how they used to eat lunch here, or they used to stay at the Divine Lorraine…. It's unbelievable the response we've gotten from the local community … there is life brought back to a lifeless place."

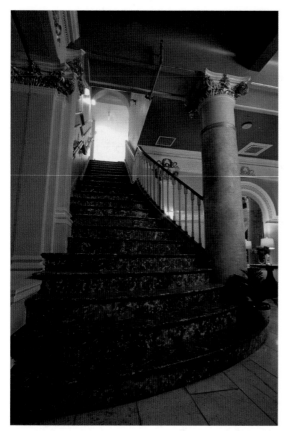

Left: The Divine Lorraine not only survives today, it flourishes, enduring as an example of what genuine intent can conceive and demonstrating how beautifully a historic building can function in a modern role. People want to see these places saved, and the key to doing so is to ensure they have an active part to play in society—that they perform at a higher purpose exceeding simply that of a preserved historic building. The Divine Lorraine Hotel pays homage to the past but is not tied down by it. It shares its stories with all who care to listen, but also encourages you to make your own. The aura of the hotel is something that cannot be purchased off a shelf and certainly cannot be built new. It only dwells in places that have stood the tests of time, in buildings that have known the world long before us and are wiser for it.

Below: "[The Divine Lorraine Hotel] is a gateway, both literally and figuratively. Yes, it connects North Broad street to South Broad street, but it also brings together a sense of community … It has roots, it has stories…. We can't be more proud of this building."

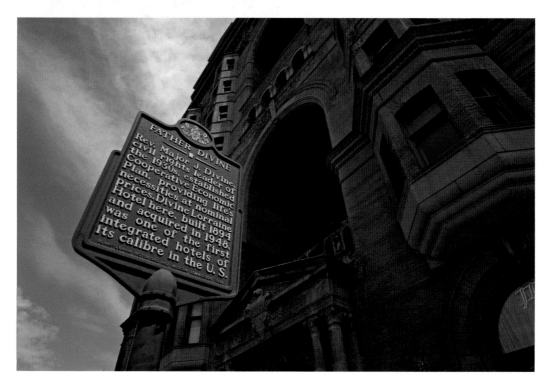

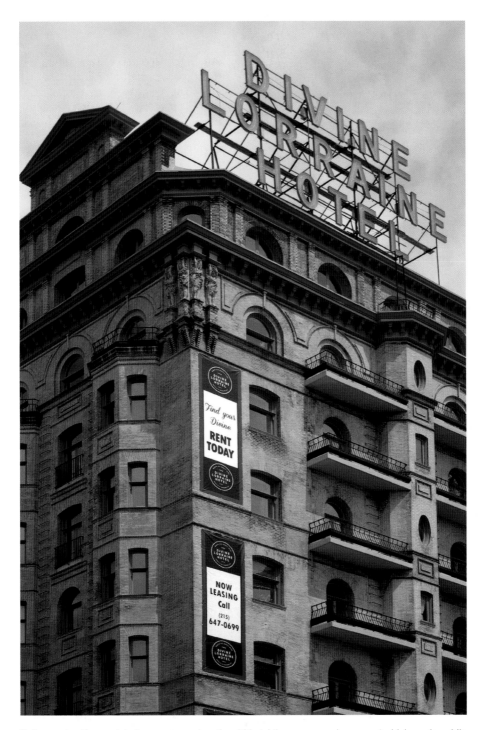

Before restoration work truly commenced on the old hotel there was a unique event which made public the intent of EB Realty, and their intentions for the building – The relighting of the original roof signage. Ed Casella recounts that stirring moment, "We had a ceremony the night we were going to relight the sign, open to all who wanted to attend. It was pouring rain but hundreds of people came out to see it." He continued, "When it lit up I got chills down my spine. There was electricity running through the building... not just the kind that powers lights."